Nikolai Gol

Irina Mamonova

Maria Haltunen

THE HERMITAGE DOGS

TREASURES FROM THE STATE HERMITAGE MUSEUM, ST PETERSBURG

Captions and annotations for the works of art
from the collection of the State Hermitage

Natalia Avetian, Alexander Babin, Irina Bagdasarova, Natalia Gritsai,
Yelena Karcheva, Alexei Larionov, Maria Menshikova, Galina Miroliubova,
Oleg Neverov, Yulia Plotnikova, Anna Savelyeva, Tatiana Safronova,
Irina Sokolova, Evelina Tarasova, Irina Ukhanova, Vasily Uspensky

Consultant
Mikhail Surbeyev,
President of the Sled-Dog Racing Federation of St Petersburg

Layout and Design
Olga Pen

English Translation
Paul Williams

CONTENTS

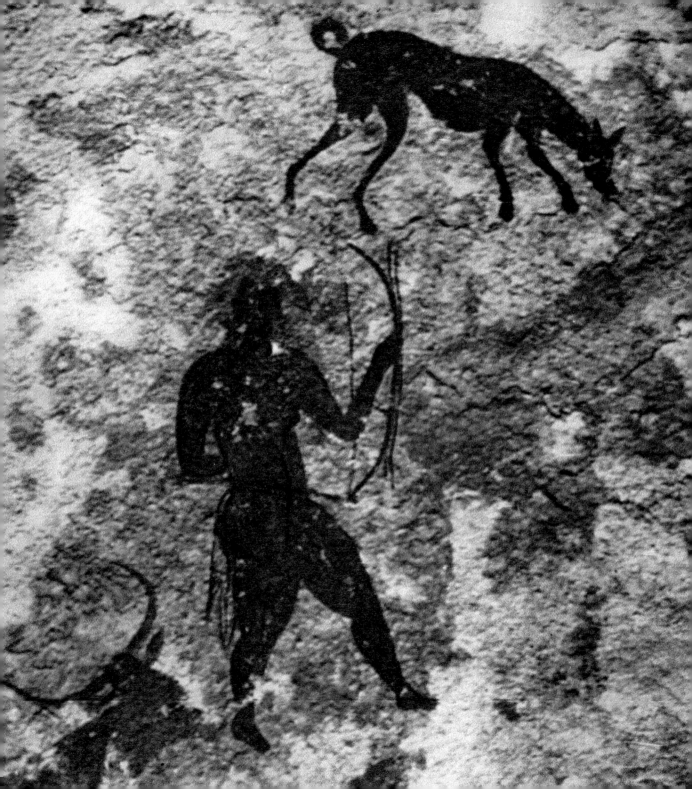

OUR FIRST ALLY

Many thousands of years ago, at the dawn of human existence, people were alone in this world. They were surrounded by the terrible and incomprehensible forces of nature while blood-thirsty predators threatened them with death at any moment.

How could ancient humans stand up to them? They did not have claws, or fangs, or even a thick hide. But they learnt to make tools and weapons, first only from stone, later from metal as well. They worked out how to use fire. They constructed dwellings. And they made allies.

◄ **Hunter with a dog**
Rock art
Sefar, Sahara desert, Africa
4th millennium BC
Detail

Someone with a dog
Rock art
Sefar, Sahara desert, Africa
4th millennium BC
Detail

People's first ally was the dog. It is hard to say exactly when our alliance began. Scholars have found signs of the domestication of the dog in archaeological layers dating from the Upper Paleolithic era (20–11,000 years ago). But very recently, in the Goyet cave in Belgium an even more ancient skull of a domestic dog was discovered. Now archaeologists are sure that for almost 32,000 years now a new kind of canid – *canis familiaris*, the domestic dog – has been living side by side with human beings.

Tamed dogs guarded the dwellings of primitive humans from wild animals and uninvited visitors. They hunted with people, helping them to find prey and the way back home, and

Birds and animals, including a dog
White Sea petroglyphs
3rd–2nd millennium BC
Detail

The rock drawings made by ancient humans that have survived down to the present include among their many subjects depictions of dogs that are perfectly recognizable and realistic.

warning of dangers. Puppies and children played together. Later when people acquired livestock, dogs began to help the herdsmen.

The warlike nomadic Scythians, who wandered the steppes north of the Black Sea in the seventh to third centuries BC, had neither settlements nor houses (they lived in portable tents) and had no need of guard dogs. But they used dogs a lot for hunting.

Incidentally *sobaka*, the Russian word for "dog", comes from the Scythian spaka. So our dogs are not only close biological relatives of the Scythians' hounds, but also close linguistic kin.

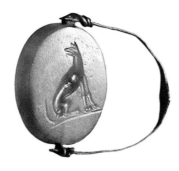

Dog
Scaraboid seal. Iran
1st half of the 4th century BC

**Scythians hunting lions
with dogs**
Silver vessel with gilded relief
4th century BC
Detail on pages 10–11

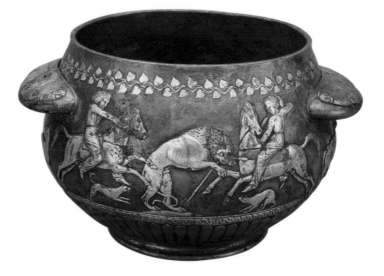

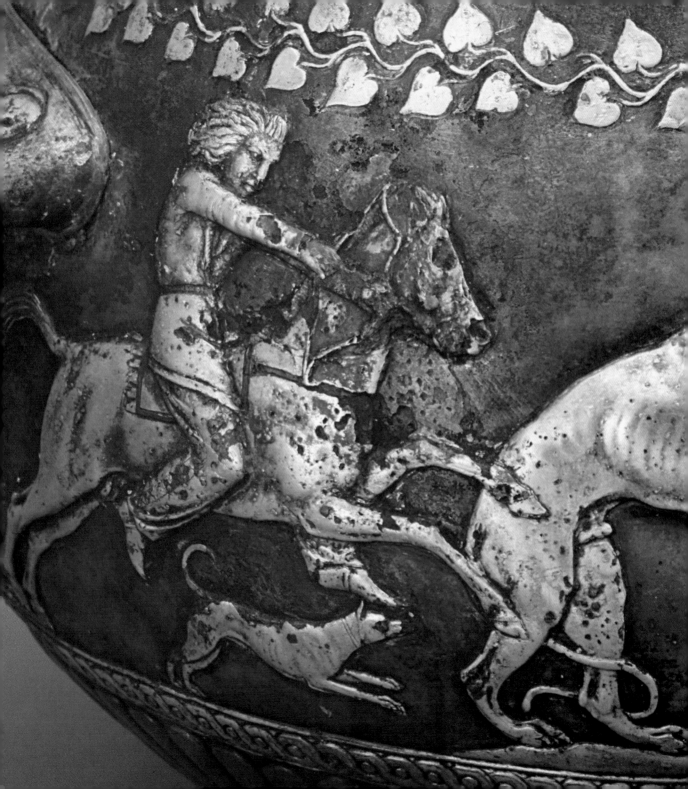

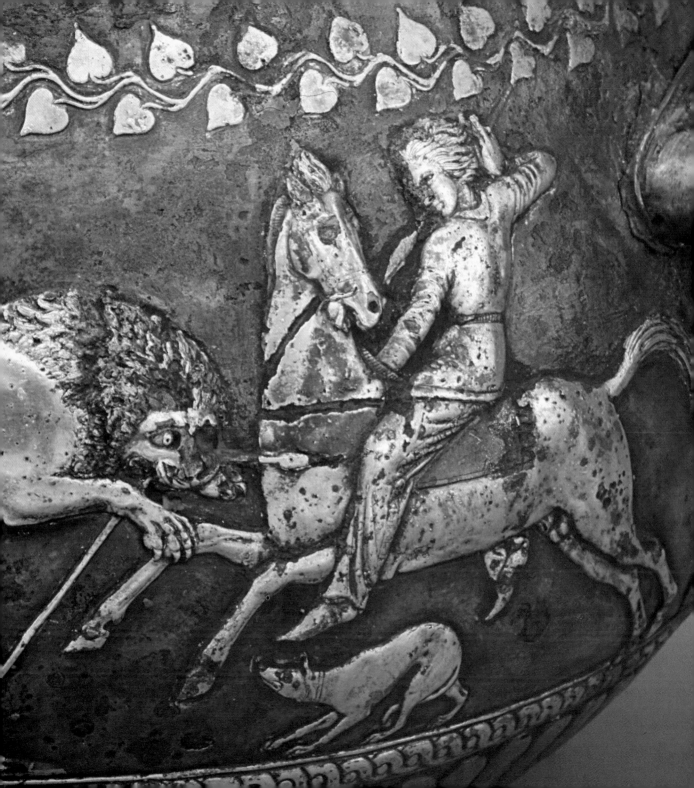

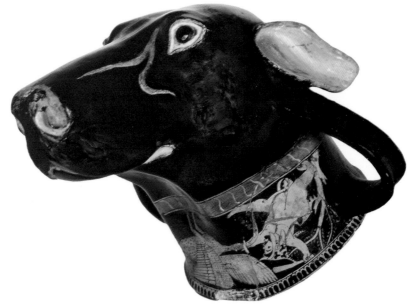

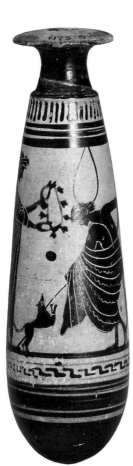

Boy with a dog

Empuries painter, Attica, Ancient Greece
Alabastron. 470s BC

*An alabastron is a small jar made of alabaster, earthenware or glass,
with a narrow neck, rounded body and loop handle by which it can
be suspended. Such vessels were made to hold aromatic oils and
perfumes.*

Rhyton in the form of a dog's head

Brygos painter, Ancient Greece. Circa 480 BC

*Rhytons (from the verb meaning "to flow") were drinking vessels
made of horn, usually used for wine. The short body of the vessel
ended in the depiction of some animal head, with a small hole in it
through which the wine would spurt directly into the drinker's mouth.*

Molossian dogs

Cameo. Ancient Greece. 1st century AD

Particularly prized in the ancient world were the savage dogs from Epirus,
a region in north-west Greece dominated by the Molossian tribe. The huge animals
of the Molossian breed were excellent guard dogs and fighting dogs, which made them
very expensive. For a long time Epirus managed to retain a monopoly by allowing
only males out of the kingdom. Descriptions of Molossians can be found in the works
of Homer, Aristotle and Plutarch.

But in the minds of ancient people there existed another canine image as well: not the real-life dog with which they shared their home and food, that could be petted or punished, put to guard the herds or set upon a wild beast, but some mysterious, incomprehensible spirit that had taken on the appearance of a dog. The spirit of the forefather.

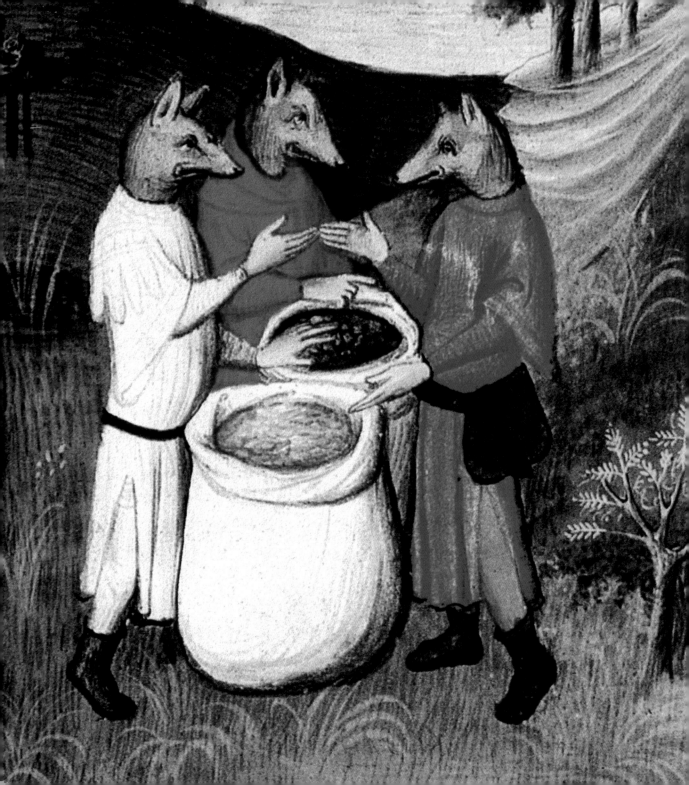

THERE IS A LITTLE DOG IN ALL OF US

Different ethnic groups, living in different parts of the planet and not in any way connected in those distant times, came up with astonishingly similar legends about humans and dogs being closely related. The natives of Alaska believed that their ancestors had been huskies. In another corner of the world the aborigines of the Indonesian island of Sumatra and the Yao people of south China also believed that they were descended from dogs. Some Scythian tribes venerated the dog as their progenitor, an older relative – the *totem*, which translates from an Amerindian language as "his clan".

Dog-headed merchants from the Andaman Islands trading fruit and grain

From Marco Polo's Books of the Marvels of the World. 1298

The Venetian traveller who spent a considerable time in the East heard that the dog-headed people were "brutal by nature and ate anyone not of their tribe." Yet trade with them was apparently well developed.

Man from a savage dog-headed tribe

From a book by Hartmann Schedel
Nuremberg, Germany. 1493

Herodotus, the "Father of History", who lived in the fifth century BC cites the testimony of "eye-witnesses" that supposedly encountered savage cynocephalic (dog-headed) tribes in India. As early as the first century BC, however, the Roman philosopher Lucretius denied the existence of beings "with a dual nature".

COMPANIONS OF GODS AND HEROES

Dogs did not achieve the status of divinity, if we disregard the Ancient Egyptian jackal deity Anubis. But time and again we find them accompanying divinities and visiting mysterious unearthly places.

Myths and legends assert that dogs quite often aided the gods in their daily affairs, in just the same way as they helped ordinary mortals.

The Ancient Greek god Hermes (Mercury to the Romans) was frequently depicted with a canine companion – as the patron of travellers and herdsmen he could not manage without a dog. Besides, Hermes was the guardian of secret knowledge and accompanied the souls of the dead into the next world, a place with which, as we shall soon see, the dog was very closely connected.

The Ancient Greek Hecate – goddess of the dark of night, dreams and witchcraft – was given to sinister nocturnal hunts with dogs. And the Greek goddess of hunting Artemis (in Roman mythology she was known as Diana) was accompanied everywhere by dogs.

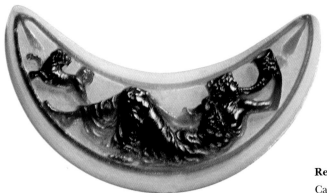

Reclining Diana the Huntress with a dog
Cameo cut from cornelian. France. 16th century

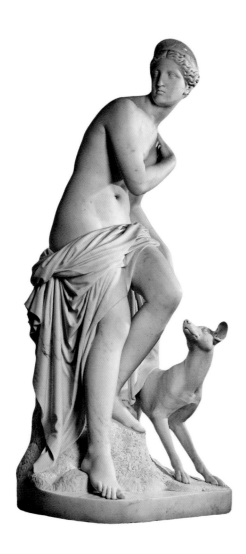

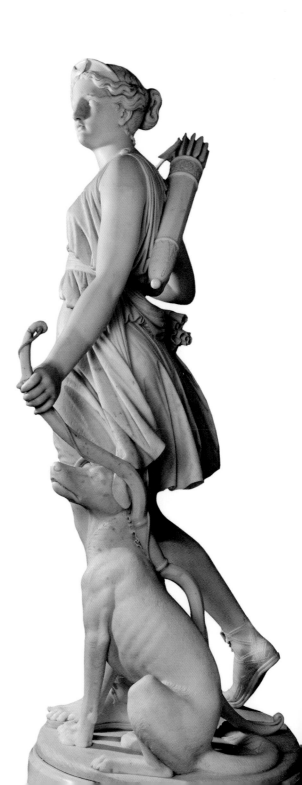

Diana before Bathing
Luigi Bienaimé. Italy. 19th century

Diana the Huntress
Luigi Bienaimé. Italy. 19th century

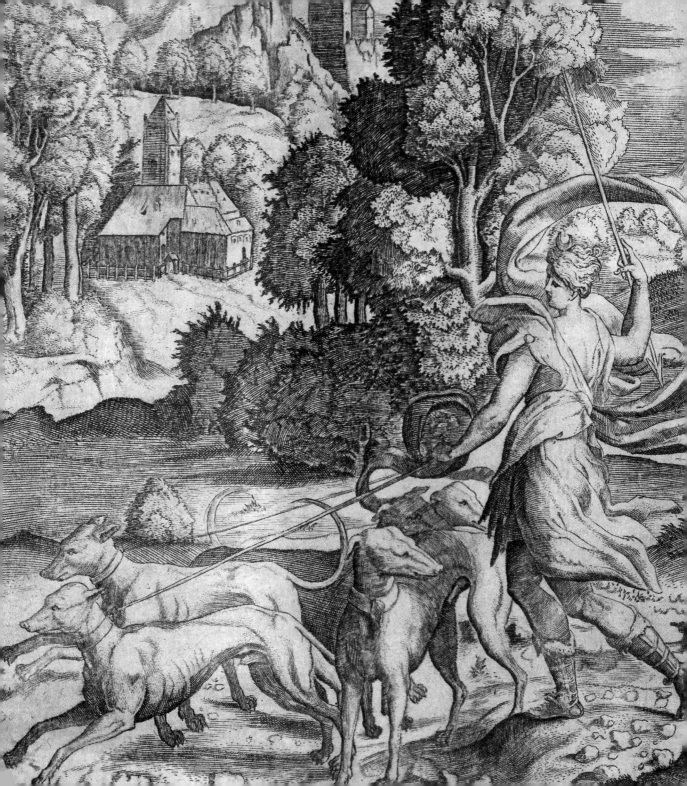

Actaeon also hunted with dogs. He may have been a mortal, but he was no ordinary one – the great god Apollo was his grandfather. The myth says that once this huntsman grew tired during the chase and entered a cool grotto, where Artemis was about to bathe in a stream.

Vexed that Actaeon had seen her naked, the goddess turned him into a stag. He fled, but Actaeon's dogs had spotted fresh prey. Tragically they failed to recognize their master in his new guise and tore him to pieces.

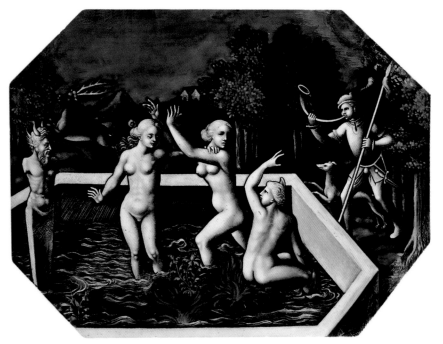

◄ **Diana the Huntress**
Vincenzo Caccianemici. Italy
First half of the 16th century. Detail

Diana and Actaeon
Martial Ydeux. France. Mid-16th century
Limoges enamel

The Hunt for the Calydonian Boar

Peter Paul Rubens (studio). Flanders. Mid-1630s. Detail

Angered by its king's failure to honour her with a sacrifice, Artemis sent a huge
savage boar to plague the Greek city-state of Calydon. It harried the inhabitants
and ruined the crops. The king summoned Greece's most celebrated heroes to hunt down
the beast. Whoever who killed it was promised its head and hide. After a bitter struggle, in which
many fell victim to the boar's tusks, the king's own son, Meleager, struck the decisive blow.
But he chivalrously ceded the prize to the huntress Atalanta, who had been
the first to wound the boar with an arrow.

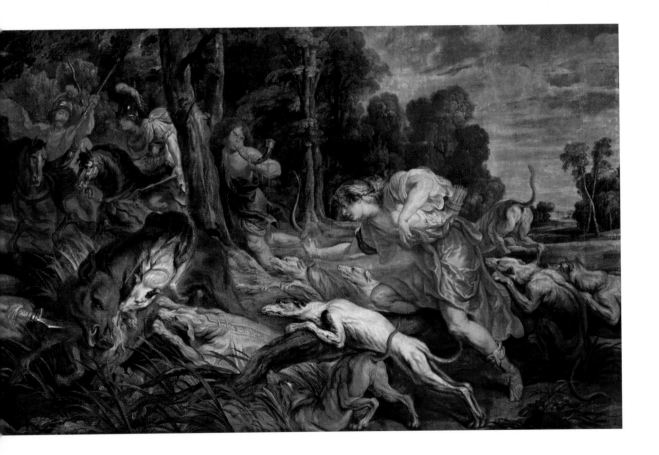

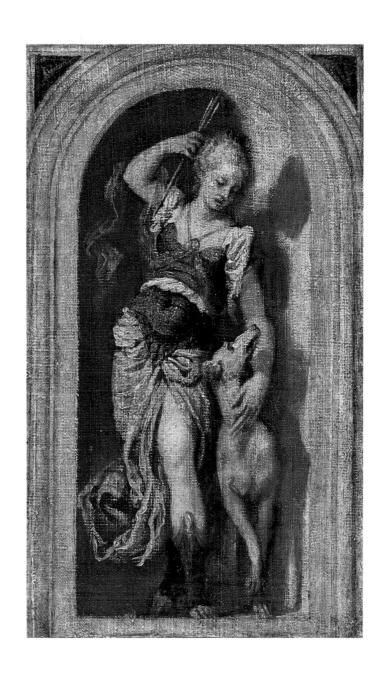

Diana
Paolo Veronese
Italy. Late 1560s

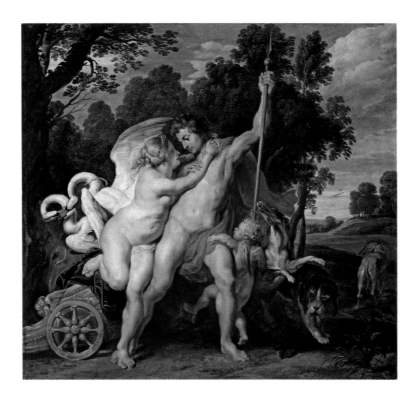

Venus and Adonis

Peter Paul Rubens. Flanders. Circa 1614

The Phoenician nature deity Adonis was customarily depicted as a handsome youth. In Ancient Greece,
to which the cult of Adonis migrated in the fifth century BC, the following myth was told about him.
The youth's good looks so impressed two females that each wanted him for herself.
These were not ordinary women, however, but the goddess of love and beauty Aphrodite
(Venus to the Romans) and Persephone, the queen of the Underworld. Zeus had to interfere
in the dispute. He commanded that Adonis should spend a third of the year on Earth
with the goddess of beauty, another third below the Earth with Persephone, while the remaining time
was his to do as he wished. Thus Adonis became an embodiment of nature, or rather of the plants
that die each autumn and reappear in spring. He often spent the earthly part of his life hunting
with hounds. In this painting we can also see a large dog harnessed to the carriage.

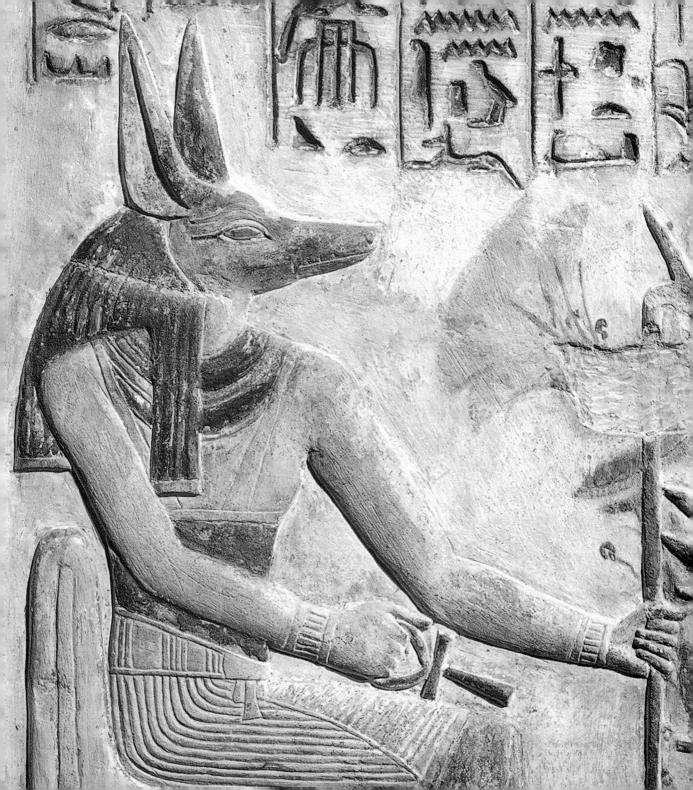

THE DOG IN THE KINGDOM OF THE DEAD

Most often, though, if the ancient myths are to be believed, dogs were in the service of the rulers of the afterlife, despite the fact that each people had its own conception of what happened to a person after death and what awaited him in the next world.

When an Ancient Egyptian died, he headed for the Duat, the kingdom of the dead. He was met on the threshold by the god Anubis in the form of a black jackal or a man with a jackal's or dog's head.

In the period of the Old Kingdom Anubis was considered the ruler of the kingdom of the dead.

"I greet you, greatest among the gods of the afterlife! I have come to you, my lord!" the dead man said, bowing before Anubis.

The god of death remained regally silent. After listening to the greeting, he led the Egyptian to a place where judgement awaited. They passed stone statues and columns entwined with living snakes. Then the last doors opened and the dead man entered the chamber of judgement, the Hall of the Two Truths.

◄ The jackal-headed god Anubis
The stela of Ipi. Ancient Egypt
New Kingdom. Mid-14th century BC
Limestone. Detail

Anubis weighing a heart at the Judgement of Osiris
The Book of the Dead. 21st dynasty. Circa 1320 BC
Drawing on papyrus. Detail

Here a person had to answer for the way he had lived his life. In one scale of the terrible balance his Eb, or 'heart body', was placed, in the other a figurine of Maat, the goddess of justice, or else her symbol – a feather. If the 'heart body', in which all a person's kind and wicked thoughts were recorded was not heavy with sin and did not outweigh the feather, a positive verdict was proclaimed: "No earthly vice has been found in his heart body. May he be given to Anubis." The person was judged worthy of resurrection, of further life, and his soul was sent to the Fields of Hetep, paradise, and his body for embalming, to become a mummy for preservation.

The inventor of mummification was believed to be Anubis himself, the ruler of the Afterlife and patron of burial mysteries. For that reason when preparing a mummy the priest put on a jackal or dog mask and became for a time the embodiment of Anubis.

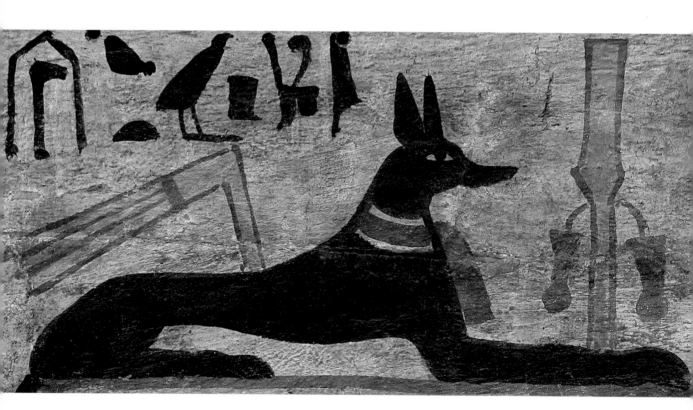

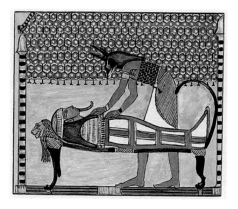

◄ Anubis
Detail on the painting of a box for ushabti figures
Ancient Egypt. 1st millennium BC

**A priest in the guise of Anubis
preparing a body for embalming**
Ancient Egypt. 13th century BC

The centre for the worship of Anubis was the city of Hardai – more often known by its Greek name: Cynopolis (literally "dog city") – where dogs were considered sacred animals. If someone from elsewhere accidentally killed a Cynopolitan dog, it was considered serious grounds for a declaration of war.

Of course, not all dogs in Ancient Egypt enjoyed equal respect. We know for certain, though, that the hunting dogs of the pharaohs and nobility that lived in the palaces were treated with great consideration all their lives. When the time came for them to go to their fellow-canid Anubis they were embalmed just like the nobles and solemnly buried in special cemeteries. Inscriptions were made on their sarcophagi, such as "The hound Abuwtiyuw, favourite of the pharaoh", found in a cemetery at Giza. This is probably the first dog whose name has come down to us across the ages.

When an ancient Hindu died, his body would be cremated on a funeral pyre and the participants of the mourning procession sang, addressing these words to Yama, the ruler of the ancient Indian realm of the dead:

We send him to you
Under the protection of the two loyal hounds
The four-eyed guardians of the roads...

This was a reference to the Sarameyas, terrible huge "hounds of hell": the four-eyed Shabar (whose name means "dappled") and his brother Udumbala ("the black one"). The pair were dogs of noble pedigree.

Their mother, Sarama ("swift") was the personal dog of Indra, one of the chief deities of the ancient Hindu pantheon, and accompanied him everywhere. When Shabar and Udumbala grew up they were given to the god Yama. From that time on, they have been keeping guard at the gates of the afterlife, neither resting nor sleeping.

When an Ancient Greek died, his friends and relatives prepared a funeral pyre and consigned the corpse to the flames, together with sacrificial animals pleasing to the gods. Pet dogs were also sacrificed.

Having propitiated the gods, the dead man's soul set off for the gloomy underground kingdom in which the god Hades or Pluto reigned. The entrance to his realm was guarded by the huge dog Cerberus, the offspring of Echidne, a half-woman, half-serpent, and the hundred-headed dragon Typhon. Cerberus had three heads, and, instead of a tail, he had a snake with open poisonous jaws. Some versions of the myth state that the great dog's entire body was covered in snake heads rather than hair.

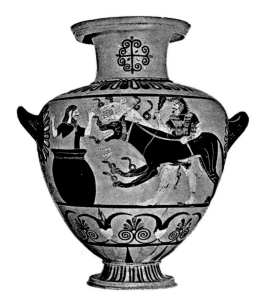

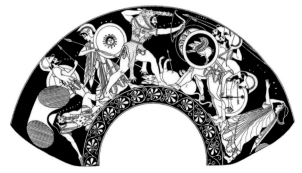

Heracles with Cerberus at Eurystheus's palace
Hydria. Ancient Greece. Circa 530 BC

Heracles defeating the two-headed dog Orthrus
Detail of the painting on a kylix. Ancient Greece. Circa 540 BC

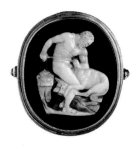

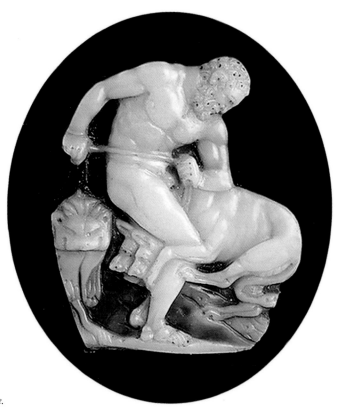

Hercules taming Cerberus

Cameo. Rome

1st century BC – 1st century AD

The craftsman has depicted the moment
when Hercules put a leash on the subjugated
monster so as to take him to Eurystheus.
Hercules is the Roman version of the hero's name.

Cerberus served his master, Hades, loyally, allowed all the dead into his kingdom and letting none back out. But there were instances when even this terrifying creature relaxed his vigilance.

The most famous victory over Cerberus was gained by Heracles, the son of Zeus and the mortal woman Alcmene. The hero was in the service of the Mycenaean king Eurystheus, who obliged him to perform twelve near-impossible labours.

The Greek scholar and writer Apollodorus, who lived in the second century BC, left the best-known description of the hero's feat. Eurystheus ordered him to capture Cerberus and bring him to his palace. Heracles set off for Laconium. Through a dark chasm by Cape Tanaerum he managed to enter the underworld. He presented himself to Hades and told

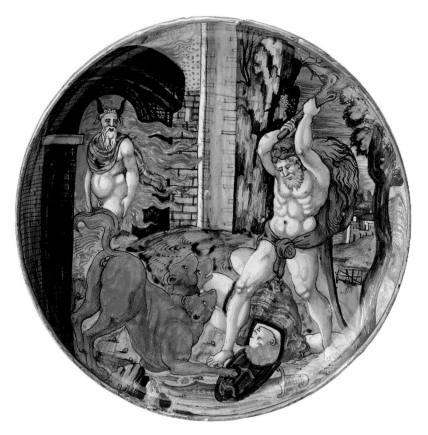

Hercules defeating Cerberus

Francesco da Rovigo
(Francesco Xanto Avelli)
Italy. 1532

him of his mission. The ruler of the kingdom of the dead promised not to hinder the hero, but with two conditions: first, Heracles will have to get the better of Cerberus bare-handed; second, he must return the beast once he has fulfilled Eurystheus's demand. The matter was settled.

When Heracles approached the exit, Cerberus pounced on him, snarling furiously and trying to tear out his throat. The hero fought back. He embraced the monster and crushed him between his mighty arms. The "hell hound" howled, tried to break free and wrapped its terrible tail around the hero's leg, but Heracles did not relax his hold. Soon the half-suffocated dog

began wheezing and went limp. Seizing Cerberus by the scruff of his necks, Heracles dragged him out through the entrance to the kingdom of the dead. The sunlight outside frightened the dog so much that he howled. Deadly foam dripped to the ground from all three of his jaws and everywhere that the drops fell, poisonous plants sprang up.

At last the walls of royal palace came into view. When he caught sight of Cerberus, Eurystheus was terrified and hid inside a great krater – a vessel that the Greeks used for mixing water and wine. He begged the hero to take the monstrous guard dog away. Heracles let the dog go, and with leaps and bounds it returned to its master, Hades, and resumed his post guarding the entrance to the kingdom of the dead.

Meanwhile the ordinary dogs of Ancient Greece performed their useful services in the land of the living: they guarded homes, protected livestock and gardens and helped hunters. The Greeks took dogs with them on walks, to feasts and public gatherings.

When an ancient Scandinavian died, he went to Niflheim, the "Abode of Mist", where he was awaited by its mistress, Hel, a bent old woman with a ferocious gaze. She was always surrounded by vicious hounds that feared nothing and no-one. The old Scandinavian epic known as *The Younger Edda* says that one of them even dared to bark at Odin, the chief god of Norse mythology, when he appeared in the realm of the goddess of death seeking his missing son Baldur.

The gigantic hound Garm in Norse mythology is also directly associated with death. In order to protect the world from this ferocious beast, the gods put Garm on a leash in the Gnipahellir cave. But at some time, so the *völvas* – shamanic prophetesses – predicted, the hound would escape and the last battle between gods and monsters would ensue, in which all (including Garm) would perish. Then Ragnarök, the end of the world, would come.

When an Aztec, an inhabitant of the mighty empire situated in the area that is the modern-day country of Mexico, died he went to the underworld known as Mictlan. The journey there was a long one. On the way the deceased had to undergo several difficult trials: avoid attacks by a huge serpent and a gigantic crocodile, slip between two falling mountains, cross eight deserts and bear an icy wind that hurled sharp stones. And all that had to be done alone. But he was helped across the last obstacle – a broad turbulent river – by a red dog belonging to the ruler of the Aztec kingdom of the dead. The *Itzcuintli* red dogs were considered sacred to him and the guides of souls in the underworld.

INTERMEDIARIES BETWEEN WORLDS

As we have seen dogs were for some reason lost to us associated with both the mysterious "other world" and the real-life world of human beings. They easily overcame the invisible boundary and were at home in this world and the other. Knowing this, human beings sometimes made use of these canine "connections".

Back in the Stone Age (10–5,000 years BC) it was customary to bury a dog together with its dead owner so that it might accompany him into the next world as a guard and protector as in this. The oldest burial of this kind was excavated by archaeologists in Palestine; later ones have been found in Africa, central Europe, China and Siberia. In Early Rus', too, some princes were buried with their favourite dogs.

Ancient humans were convinced that a dog would help them "reach agreement" with the supernatural forces that bring disease and death. And they sent a dog instead of themselves or their kin.

The Iroquois of North America, for example, gave added force to the prayers that they addressed at the New Year to the spirits and gods of the other world by sacrificing a white dog.

The Nganasans, nomadic hunters and herders who live on the Taymyr peninsula by the Arctic Ocean, had a similar custom: they sacrificed a dog after putting a rope leash around its neck. The shaman pronounced these words: "We send our dog to the spirit Syudi-nguo and may she in turn give people good hunting." The leash was needed for the female spirit Syudi to lead the gift back to her dwelling place.

Similar rites were practised by the Nivkhs, another native people of the north, direct descendants of the Stone Age inhabitants of Sakhalin and the lower reaches of the River Amur. These highly experienced hunters and fishers, also have a long history of breeding dogs and using them as draught animals. When they sacrificed a dog to the spirits, they

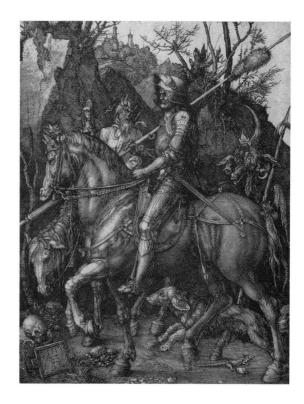

Knight, Death and the Devil
Albrecht Dürer
Germany. 1513

*The German knight depicted in the engraving is deep
in thought and although he is still alive everything
around points to the end of his earthly existence,
particularly the skull and the figure of Death with
an hourglass. The faithful dog accompanies his master
on this last journey.*

Detail on pages 34–35

would say: "Let this dog go to the Mountain Man and tell him: 'Do not harm my master;
take me instead.'"

In the Western Himalayas at the New Year people took a dog to the threshold, gave it a piece
of bread and then drove it away, saying: "Be gone, dog! If in this year the spirits wish to send
misfortune upon our home, may it come down upon your head!"

The Zoroastrians, followers of the ancient Iranian religion, have a different way of obtaining the favour of the dog that guides the souls of the dead into the next world across the tricky
Chinvat bridge. A righteous person will cross easily and enter paradise, but a sinner will slip off
into the abyss of hell. In the hope of help from the dog at that critical moment, each Zoroastrian will try to feed some canine at least once a day.

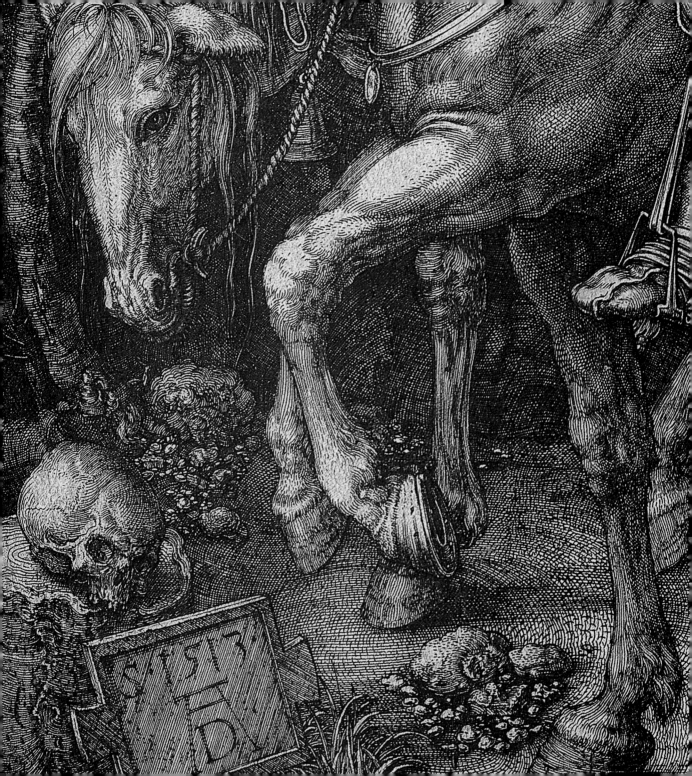

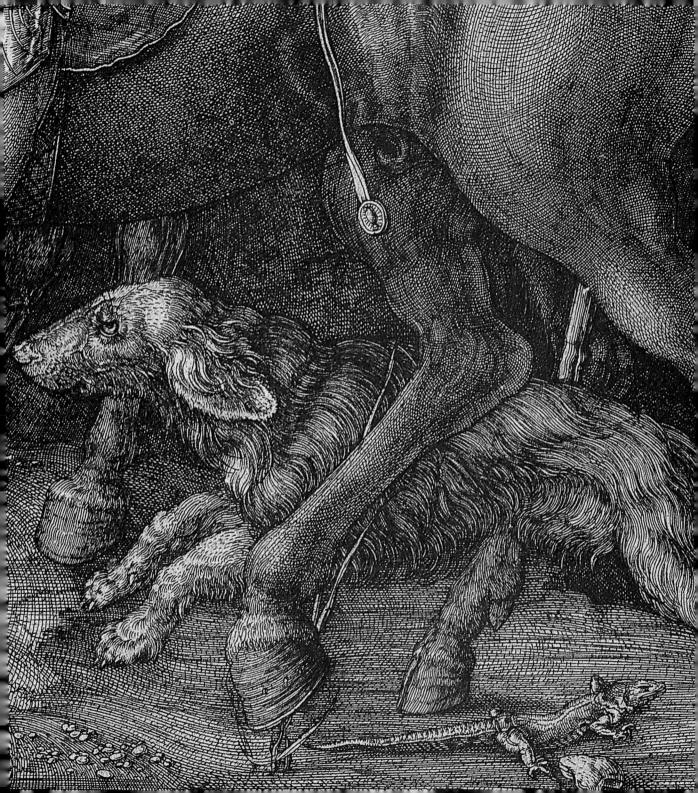

DOGS IN THE CALENDAR AND THE HEAVENS

Way back in ancient times dogs found their way into the calendars used in many countries.

In the South-East Asian calendar, created thousands of years ago and still in use in China, Japan, Vietnam, Korea, Mongolia, Thailand and a few other countries, time is reckoned in twelve-year cycles and each year is dedicated to some particular animal.

The eleventh year of each cycle is the Year of the Dog. It is believed that people who are born in these years are loyal, determined, responsive and rigorous in fulfilling their obligations, but also unsociable and disinclined to express their feelings openly. Many of those qualities strongly apply to dogs as well.

In the Aztec calendar the tenth week of the year was associated with dogs. It was called *Itzcuintli* and devoted, naturally, to remembrance of the dead.

The Ancient Roman calendar, like any other, was based upon the movements of heavenly bodies. When the Romans looked up at the night sky they did not see simply a scattering of stars, but whole scenes and pictures. Here a pair of hounds strain at the huntsman's leash as they pursue their prey – the constellation called *Canes Venatici*, the "hunting dogs". There a small dog stands quietly resting – *Canis Minor*. And over there a larger dog is sitting down – *Canis Major*. According to one legend a dog named Maera was transformed into this constellation by the god Dionysus for exceptionally loyal service to the Athenian shepherd Ikarios. The brightest star in this constellation (indeed in the whole firmament) is now known as Sirius, but the Romans affectionately called it *Canicula* – the little dog.

Figurines of the calendar animals in a ceramic shop
Suzuki Harunobu. Japan. 1764–66. Detail

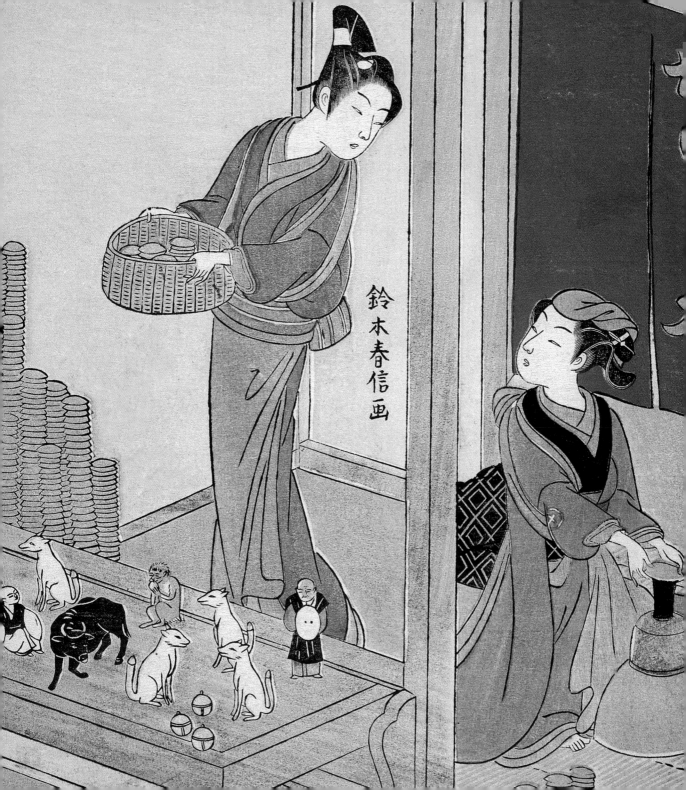

鈴木春信画

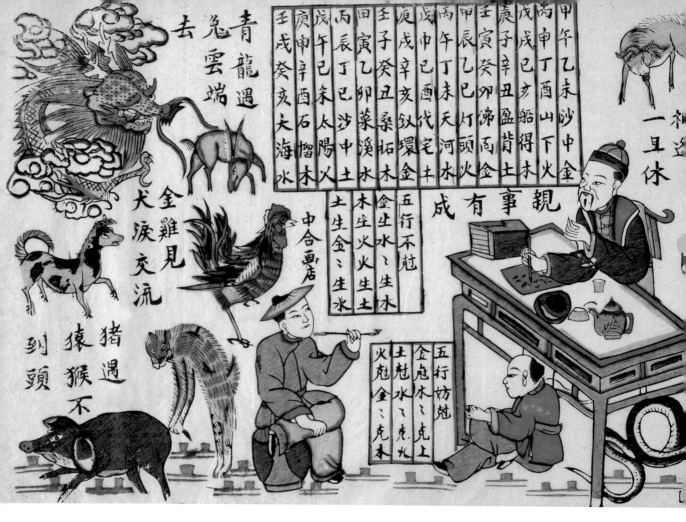

Drawing up a horoscope

Chinese folk picture. Late 19th – early 20th century. Detail

*The inhabitants of China would not take a single important decision without consulting
an astrologer. If the bride and groom were born under incompatible signs, the marriage would
not be happy. Those born in the Year of the Dog, for example, are recommended not to marry
a Rooster because the Rooster will know nothing but sorrow (in the picture the cockerel
is running from the dog). That is what astrologers say.*

In summer when Sirius was visible above the horizon, it became so hot in Rome that all the city's institutions took a break from work – the "dog days" or *caniculi*. This word was taken up in Russian and is now used for school (and other) holidays.

The ancient Sumerians called Sirius "the dog of the Sun". The Ancient Greeks, imitating the Egyptians, made sacrifices to Sirius so that the blistering heat might not destroy the crops, livestock and people. The appearance of Sirius above the horizon was the start of the New Year for the Athenians.

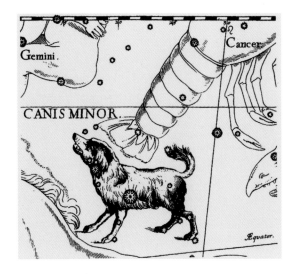

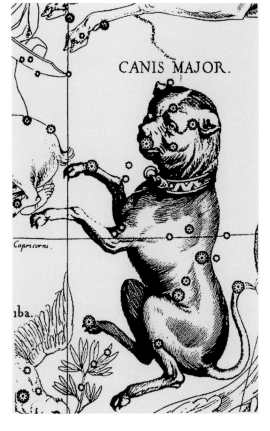

The constellations of Canis Minor and Canis Major
From Johannes Hevelius's *Firmamentum Sobiescianum or Uranographia,* an atlas of constellations published in 1690
Details

PURE AND IMPURE

Different religions have taken different attitudes to dogs: in some they are venerated, in others they are disapproved of and numbered among the "impure" animals.

The Old Testament does not have a single favourable word to say about dogs. Isaiah compares false prophets to them; King Solomon uses them as a likeness for sinners. In the Psalms David complains "Dogs have surrounded me; a band of evil men has encircled me…"

According to the Law of Moses, to compare anyone to a dog was a great insult. When he saw the shepherd boy David approach him with a sling and a staff, the Philistine giant Goliath shouted out, "Am I a dog that you come at me with sticks?" In other words, a dog was a despicable creature worthy of being beaten with sticks. It was forbidden not only to give money obtained from selling a dog as an offering in the temple, but even to carry it into the House of the Lord God, the tabernacle.

This attitude did not, however, prevent Noah from taking a pair of dogs onto the ark before the Great Flood, so that they were saved with the other animals to renew life on the Earth.

In Islam, too, the dog has always been considered an unclean beast. Although even then not all animals are equal. A yard, street or even guard dog would not be allowed into the house in Islamic countries, but hunting dogs, especially salukis, have always enjoyed great respect. They even feature in an Arabic proverb: "A fine falcon, a noble steed and a swift dog are dearer than twenty wives."

Still, the jocular English way of familiarly addressing someone as "old dog" would even today be taken as a grave insult by a Jew or a Muslim.

Yet nowhere at any time was there a strict ban on having contact with dogs. And that would be impossible. How would people get by without them? Religion is one thing, but practical daily existence is another.

The Talmud, the fundamental book of Judaism containing interpretations of the Old Testament and the laws, instructive examples from history and even rules for everyday behaviour, includes a parable that has a direct connection with our theme.

A certain celebrated rabbi was once visiting a family for a meal and naturally he was given the place of greatest honour at the table. Imagine his surprise, then, when he saw a dog alongside him.

Insulted, he got up to leave, but his host hastened to explain. It turned out that some time before the house had been attacked by robbers and the family had escaped harm only thanks to this guard dog. "Since then he has always eaten with us," said the host, concluding his tale. After some thought, the rabbi agreed that the dog had earned his place and that he himself had no cause to take offence.

The New Testament has nothing positive to say about dogs either: Matthew's Gospel calls pagans dogs, the apostle Peter uses the word to describe sinners. But there is another explanation. In his conversation with the Canaanite woman Jesus compares pagans with dogs, with domestic animals, while his own followers are the children of God.

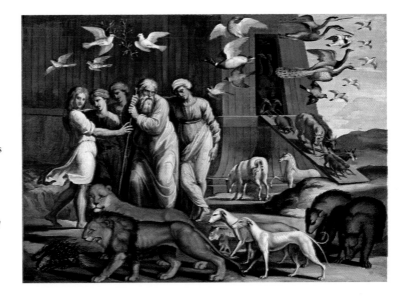

The rescued animals leaving Noah's Ark after the flood waters subsided
Christopher Unterberger
1778–88
Copy of a mural in the Vatican's Raphael Loggias

According to one legend, the dog blocked a small leak in the Ark with its nose. In memory of this noble deed since then all dogs have had cold, wet noses.

Detail on pages 42–43

41

In the history of Christianity dogs have often been perceived as helpmates of Satan or one of the possible embodiments of demons. In the accounts of the lives of saints one quite frequently comes across a description of a demon in canine guise visiting hermits during their prayers and trying to distract them. The forces of evil first appear to the central character of Goethe's *Faust* in the shape of a black poodle. Initially the dog seems sweet and not at all dangerous, but suddenly

> *In length and breadth how doth my poodle grow!*
> *He lifts himself with threat'ning mien,*
> *In likeness of a dog no longer seen!*

and the tempter Mephistopheles presents himself to Doctor Faust.

With time the Christian attitude to dogs changed somewhat, but it acquired an ambiguous character.

In mediaeval Christian Europe the dog became a symbol of devotion to Church dogma. The Dominicans, a monastic order founded in 1215 by Dominic de Guzman, took as its emblem black and white dogs. A certain role in this choice was played by the phonetic similarity between the Latin name for the monks "*Dominicani*" and the words "*Domini canes*", meaning "the dogs of the Lord". In keeping with this choice of symbol, the Dominicans mercilessly hunted down any sort of heresy in close collaboration with the Inquisition. The dog, as a symbol of devotion to the faith, was also depicted on the hilts of many Crusaders' swords.

Dogs acquired a highly distinctive meaning in Russia during the reign of Ivan the Terrible. Those men who became members of the Tsar's personal punitive force, the infamous *oprichniki*, were required "while riding to have a dog's head on the neck of the horse and a broom at the whip-handle". The dog's head symbolized the *oprichniki's* ability to sniff out and then gnaw out treason, and the broom their duty to sweep away those in disfavour, to rid the realm of dissent. Here, of course, the devotion is not to God, but a blind, dog-like devotion to the service of the autocrat.

Among old Russian icons it is possible to come across depictions of a saint with a dog's head and a human body. This is the well-known martyr Christopher.

There are several versions of the legend of St Christopher: they differ particularly between the Western (Catholic) and Eastern (Orthodox) Churches. The best known Greco-Slavonic account states that before becoming Christopher, he was a man of enormous height "from a dog-headed clan, from a land of cannibals" (presumably taken prisoner in eastern Egypt),

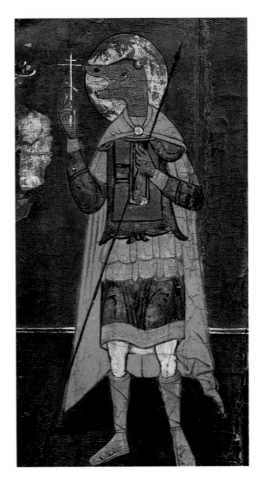

St Christopher with a Dog's Head

Detail of an icon. Totma, Russia. 16th century

Ancient manuals for icon-painters contain curious instructions on how to paint Christopher: "A dog's head, dressed in armour, a cross in one hand, a sword and sheath in the other" or "A dog's head, shoulder-length hair like a maiden, in the right hand a cross, in the left a spear that has blossomed."
Saint Christopher was also considered a protector against infectious diseases and epidemics.

and they called him Reprev, meaning "unfit, rejected". He did not possess human speech, but was humble in his character. Once an angel touched his lips and Reprev acquired the power of speech. And that was not the only miracle in the life of the future saint. He was baptised by moisture that miraculously poured from a cloud and was given the name Christopher – "the bearer of Christ". At this the staff he held in his hand put out green shoots, which was seen as a sign of God's particular favour. From that moment Christopher "became firm in the faith

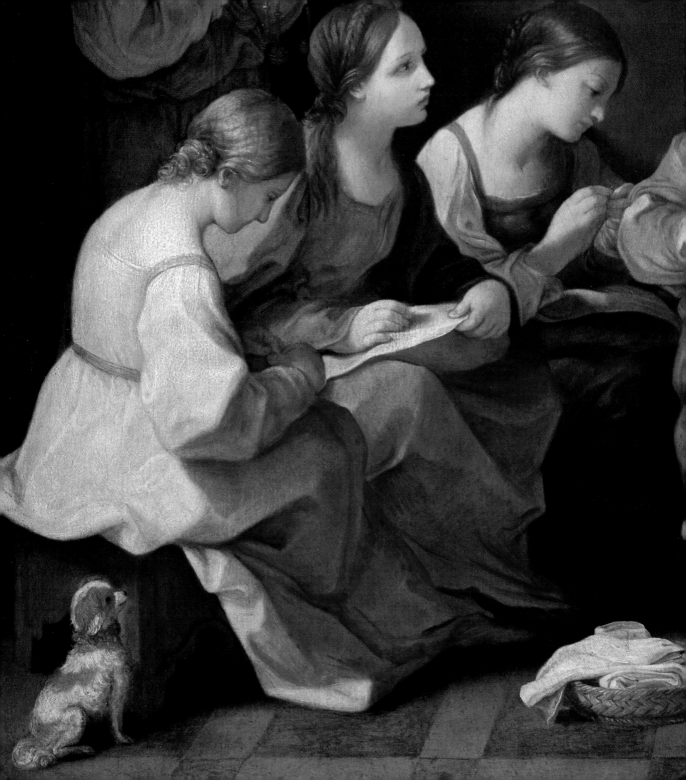

and constantly praised God." According to one version of the legend, he also acquired human appearance at his baptism.

In the third century Emperor Decius, a persecutor of the Christians, ordered that Christopher be brought before him and in order to make the giant turn from Christ he had him subjected to terrible tortures: the wretched man was hung up by his hair, burnt with red-hot irons, tempted by beautiful harlots and roasted in a copper vessel. But Christopher remained steadfast and unharmed. Having failed to make Christopher recant, Decius ordered him to be beheaded.

On icons from the sixteenth and seventeenth centuries Christopher is quite often depicted with a dog's head. But many were disturbed by the bestial appearance of a great martyr. In 1746 Metropolitan Antony of Rostov made a formal request to the Holy Synod that it give instructions to rework the dog-headed depiction of Christopher on icons "and not to paint such in future so that dogs' heads might not be venerated instead of Christopher."

In the fine arts images of dogs quite often occur in Christian subjects, although dogs are still not allowed into Orthodox churches and monasteries.

**The Girlhood
of the Virgin**
Guido Reni. Italy. 1640–42

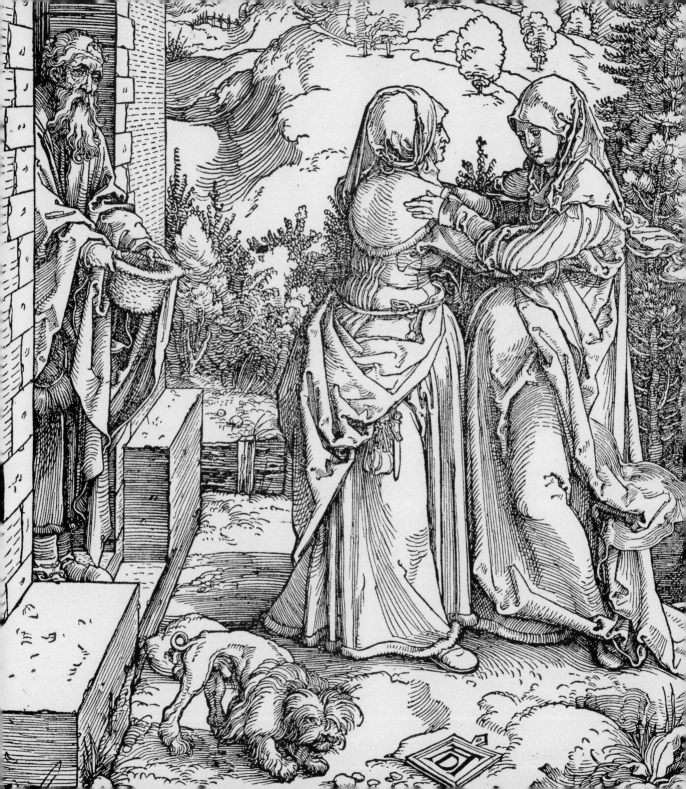

 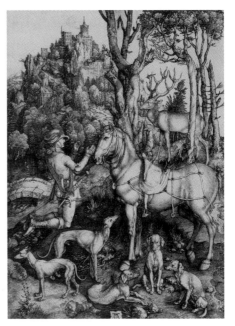

The Visitation

Albrecht Dürer. Germany. 1502–05

The traditional subject of Mary visiting her cousin Elizabeth before the birth
of their children, John the Baptist and Jesus.

Saint Eustace

Albrecht Dürer. Germany. 1502–05. Detail on pages 50–51

The Roman general Placidus, who lived in the reign of Emperor Trajan, went out hunting one day. He and his hounds
chased for a long time a particularly large stag. When the hunter had almost caught up with his prey, the stag suddenly
stopped on a hill, turned and spoke with a human voice: "Why are you chasing me, Placidus?" Between its antlers he could
see a crucifix. The amazed Placidus slipped from his horse to the ground. The stag disappeared, but the mysterious voice
continued to speak. This miraculous vision completely changed the general, who had himself and his family baptised,
taking with the name Eustace. An account of the saint's astonishing life was drawn up in the seventh century.
Depictions of him from the tenth century survive in Rome, as well as in churches in Cappadocia, Georgia and other lands.
In late mediaeval Europe Eustace was considered the patron saint of hunters and foresters.

The dog was perceived at one and the same time as both the bearer of goodness and as the embodiment of evil and dark forces. It depended whom it served. Tsar Ivan the Terrible, who has already been mentioned, compared to dogs both the unquestioning executors of his royal will and his opponents, whom he called "stinking curs".

The ambiguous view of the dog was reflected not just in religion, culture and art, but even in the language. We speak of "dog-like devotion", meaning slavish, blind, thoughtless. There is "barking mad" and "barking up the wrong tree". A "dog's life" is one not fit to be lived, while to be "in the doghouse" is to be in disfavour with someone.

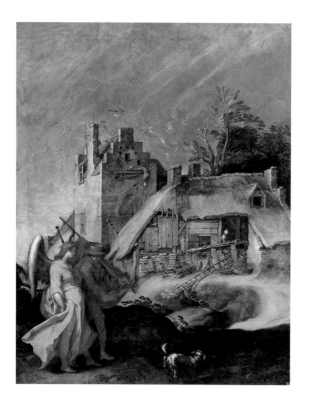

Landscape with Tobias and the Angel
Abraham Bloemaert
Holland. Early 1600s

A story from Old Testament times tells of the wanderings of the youth Tobias, who was sent on an important mission by his aged blind father. Concerned about his son's safety, the old man requests a reliable companion for his son on the long and dangerous journey. Such a companion appears, but, unbeknown to Tobias, it is the angel Raphael. As one might expect, the angel is of great help to the youth and everything ends happily. But the pair had one more companion: the loyal dog that humbly accompanied Tobias wherever he went as an envoy of his loving home, a sign of his parents' blessing.

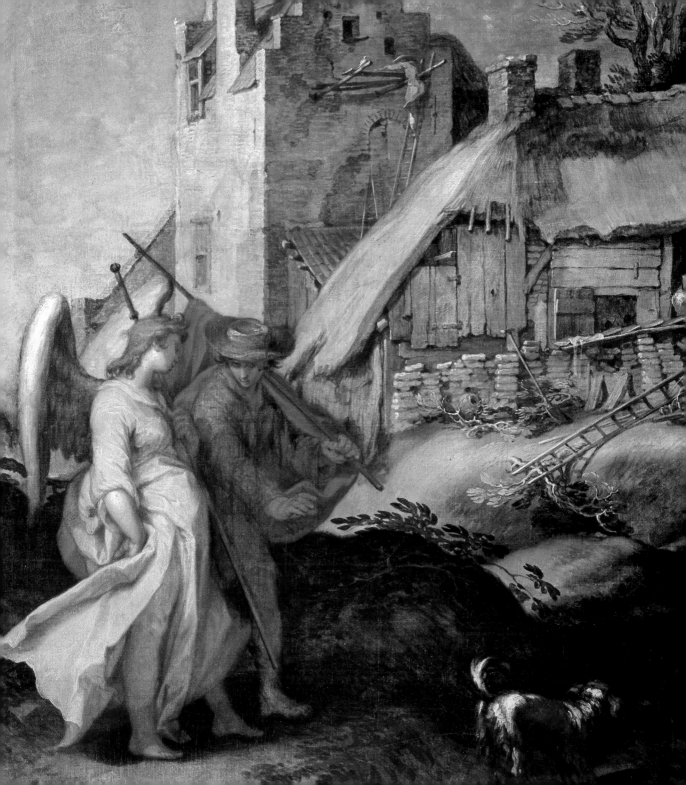

DOGS: SYMBOLS AND ALLEGORIES

Art has its own secret language – the language of allegories and symbols.

An **allegory** (from an Ancient Greek word meaning "to say otherwise") is an allusion, a way of expressing some abstract idea through a concrete image. For example, the concept of "strength" is expressed in allegorical terms by the image of a lion; an allegory of wisdom is provided by the owl that can see in the dark and whose mind is active when others sleep, justice is allegorically depicted in the form of a woman with a pair of scales (carefully weighing all the evidence for and against) and a blindfold (indicating that judgement is unbiased, irrespective of persons, one for all).

A **symbol** (from an Ancient Greek word meaning "a sign") is a conventional device representing some concept or phenomenon. It is a part of some whole that completely expresses its inner essence. The symbol is an outward characteristic from which it is possible to divine the deeper meaning of something. It gives a hint, but only to those who know the secret language. A symbol can be a phenomenon, an object (such as olive branch standing for peace, or an inverted torch as a symbol of death), a shape (the circle as a symbol of perfection and completeness), or a colour (in antiquity light blue symbolized the spiritual dimension, the heavenly origin of those depicted in blue clothing).

But the meaning of symbols is not fixed once and for all. The symbolic meaning of one and the same object can be different in different cultures. It can also change with time or depending on the presence of other objects and its location in the picture.

The Wedding Feast at Cana
Benvenuto Tisi (Il Garofalo). Italy. 1531
Detail

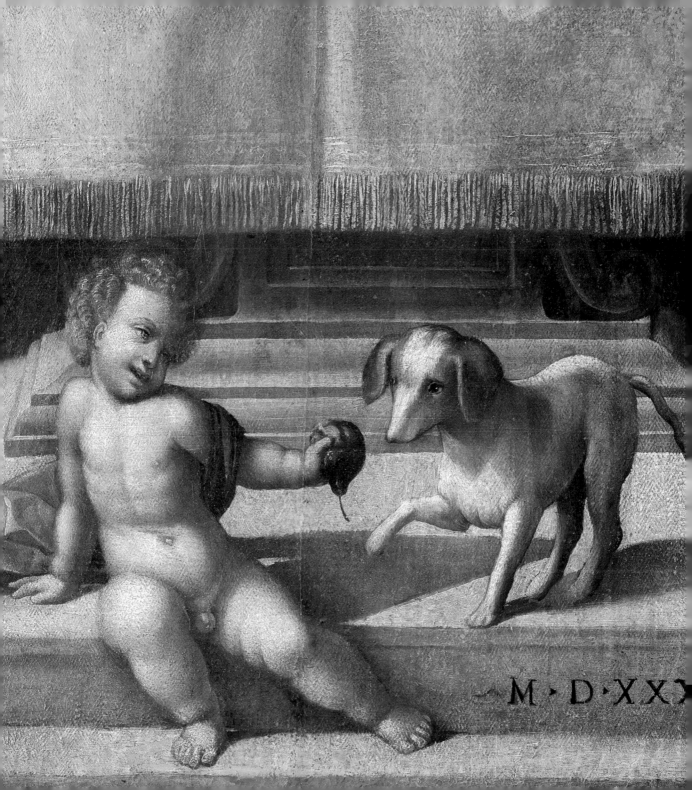

M·D·XXX

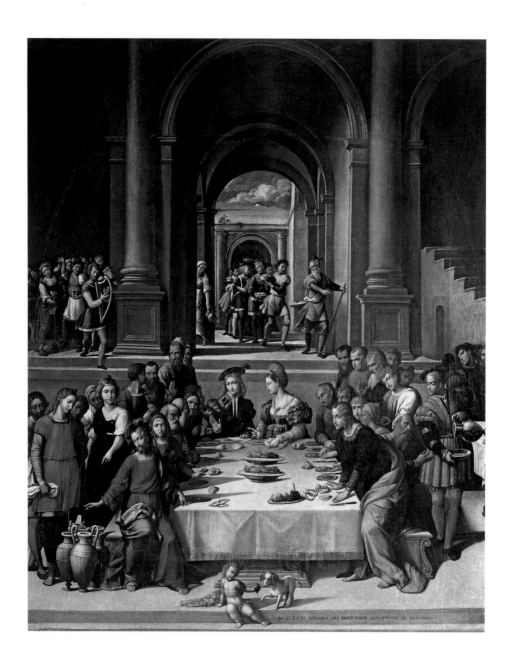

For example, in Ancient Greece and Rome white was considered a symbol of death, the colour of mourning, while in Byzantium and in Early Russian art white clothing symbolized purity, holiness and the salvation of the soul. In other traditions white stood for rebirth: the white dress of a bride, for example, symbolized not only her purity, but also the death of one life and birth into a new one, in a new capacity.

Depictions of dogs also form part of the symbolic language. In the twelfth century the dog became a symbol of European Crusader knights. It demonstrated their readiness to follow the name and banner of the Lord with dog-like devotion. Depictions of dogs can also be seen on the surviving tombs of Crusaders. A century later the newly-formed Dominican Order and its founder chose as their symbol a dog with a burning torch in its mouth, representing the ardent faith of its members.

In heraldic compositions hounds symbolized the nobility and dignity of the owners of a coat of arms. On family tombs the depiction of a little dog at a lady's feet symbolized marital fidelity.

In the early Middle Ages a language of symbols also began to form in pictorial art. Between the fifteenth and seventeenth centuries Western European culture generally was filled with symbols and allegories. Depictions of ordinary household objects, vegetables, fruit, insects and animals acquired an additional, hidden meaning. Among these many symbolic objects the dog also had its place.

The Wedding Feast at Cana
Benvenuto Tisi (Il Garofalo). Italy. 1531

The little dog and the infant Cupid, son of Venus, the goddess of love,
play on the shallow step in front of the dining-table. The artist has depicted
a well known subject – the wedding feats at Cana in Galilee, where Christ was
an invited guest and where he performed his first miracle: turning water into wine.
The subject is one that besides its religious meaning allowed artists to stress
the importance of family ties. In sixteenth- and seventeenth-century painting a small dog
was a favourite animal for inclusion in marital contexts – paintings of couples
and wedding scenes. It served as a symbol of the fidelity and constancy of the newly-weds.

DOGS: SYMBOLS AND ALLEGORIES

An Allegory of a Virtuous Life
Hendrik van Balen, Jan Breughel the Younger
Flanders. 1625–26

A little dog is placed in the foreground of this elaborately constructed
painted allegory with a host of details.
Often in works of this period the meaning of the depiction is revealed
though the juxtaposing of personages. The dog here is a counterpart to the monkey
that is holding a peach. In European painting a monkey quite often embodied human vices
and the depiction of one with a fruit may be a reference to the Fall. The dog, on the other hand,
symbolizes the watchfulness and piety of a believer. Thus the two animals together represent
the conflicting choice between the right and wrong courses, between sin and virtue.

Family Portrait
Bartholomeus van der Helst
Holland. 1642
Detail

*In the seventeenth century a family portrait was not expected
to convey the deep emotions of the subjects or the subtleties
of their mutual relationships. Most often the personages
are deliberately posing, demonstrating their wealth, dignity
and social standing. In this portrait the parents and their
child look entirely natural and even happy.
The dogs are concerned with one another and are not
an example of obedience, but they complement the general
living harmony and at the same time serve as a reminder
of family values: love, devotion and fidelity.*

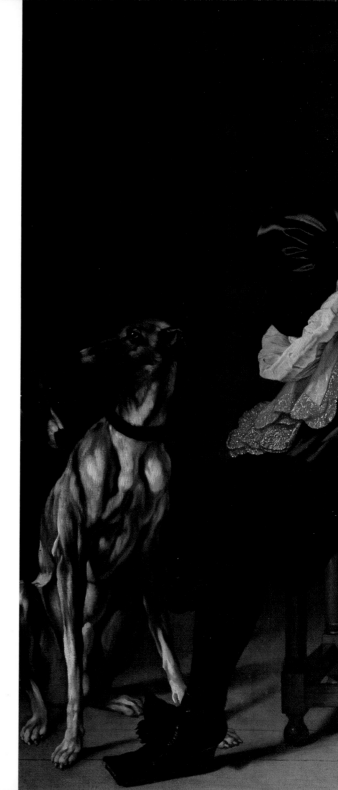

The Presentation of the New Bride

Bartholomeus van der Helst
Holland. 1647

*This formal family portrait depicts the psychologically difficult moment
when two generations meet: the parents and the newly-weds. The mother evidently
is not very pleased with her son's choice. It is most likely in order not to betray
her feelings that she avoids looking at her daughter-in-law. Next to the parents
are splendid hunting dogs. They are evidence of the well established foundations
of the older couple's family life: its prosperity, comfort and amusements.
The face of the young woman is frozen from anxiety in an expression of confusion.
Her husband tries to give her confidence. Going ahead of the young couple,
but with some shyness on entering someone else's territory, is a little lap dog.
It is a symbol of the fidelity and reliability in the young couple's relationship.
The father is trying to persuade the mother of something, while his son seems
to be trying to encourage his wife. That is what the poses and gestures say, but not
the looks! The personages are depicted in such a way that each of their gazes goes past
the other, as if an invisible wall exists between them. And it is only the little dog frozen in
the centre of the painting that is looking with interest directly at the big hounds
in the family that it is to enter. For their part, they feel themselves to be the masters
here and disdain to notice such trifles.
The pose of the little dog and its open, lively gaze, full of curiosity and excitement,
seem to convey the feelings and emotions of the humans. Its figure is placed and lit
in such a way that it links the two worlds, the two parts of the painting, into a single
whole. The artist seems to be suggesting that there is a chance that
the two generations will get along.*

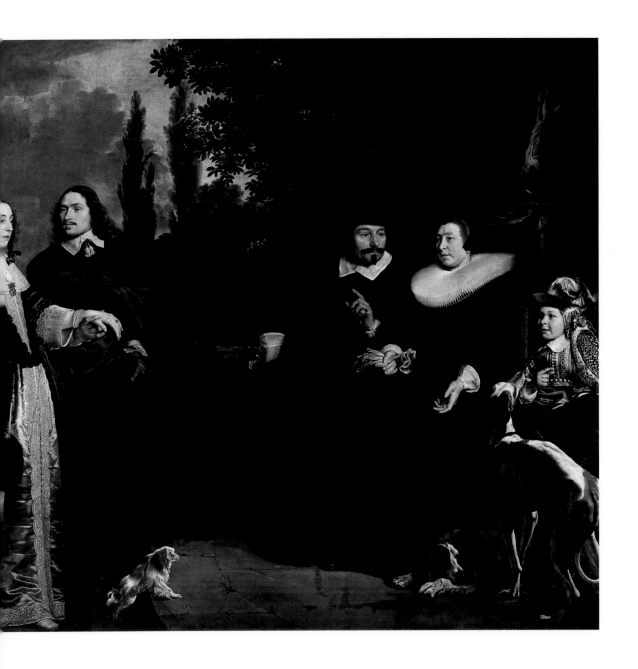

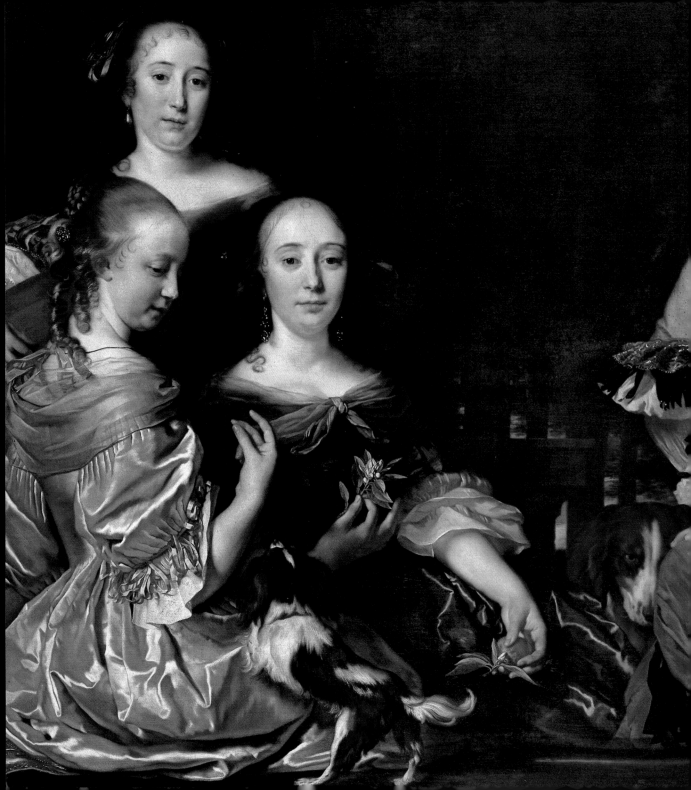

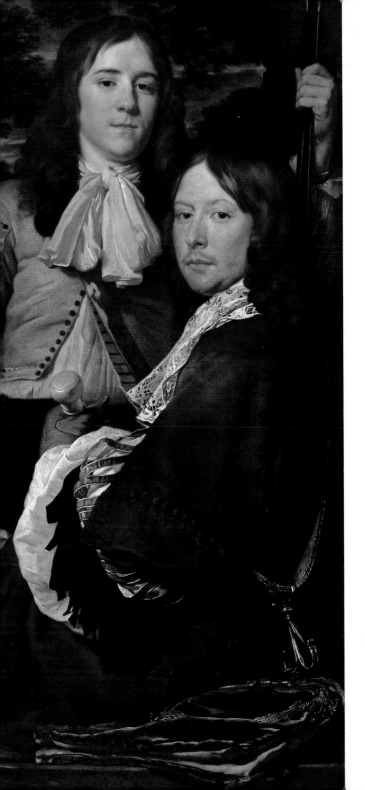

Family Portrait
Abraham Lambertsz van den Tempel
Holland. Second half of the 1660s
Detail

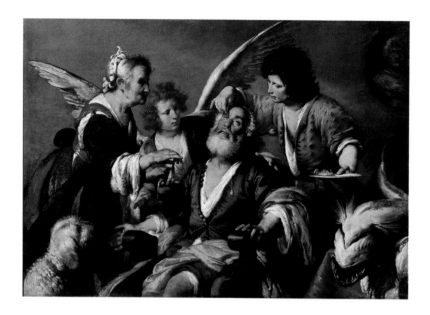

The Healing of Tobit

Bernardo Strozzi. Italy. 1635

This is another subject of Old Testament days from the Book of Tobit.
The blind old Tobit was obliged to send his beloved son Tobias on a long and dangerous journey.
Miraculously the youth was escorted on his mission by an angel in the disguise of a young man. They were
also accompanied by a dog sent by his father. Despite serious difficulties, all Tobit's errands were fulfilled.
The son, his companion and the devoted dog returned home safe and sound. Moreover during the journey Tobias
caught a huge fish parts of which he brought home on the angel's advice in order to restore his father's sight.
It is this moment that the painting depicts. Tobias and his mother anoint the old man's eyes with the gall
of the strange fish and effect a cure. Their careful movements, concerned faces and concentrated looks
are evidence of the mutual love and harmony reigning in the home. The spread wings of the angel seem
to form a canopy over the entire family and indicate the presence of Divine Grace.
The dog (in the left foreground) is watching attentively what is taking place and is clearly as emotionally
involved as the rest. The open palm of the not yet fully cured Tobit is extended to the dog – even at such a moment
he remembers about it. He is grateful to the animal that has also completed the dangerous journey and is now
a participant in the miraculous healing of the master of the house. Love, loyalty devotion and reliability –
all those marks of a real family are embodied here by the dog.

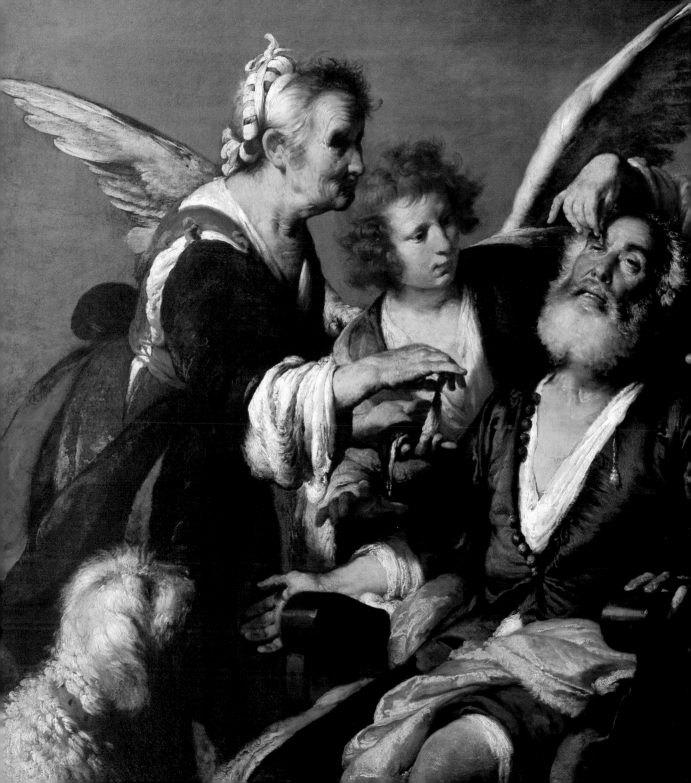

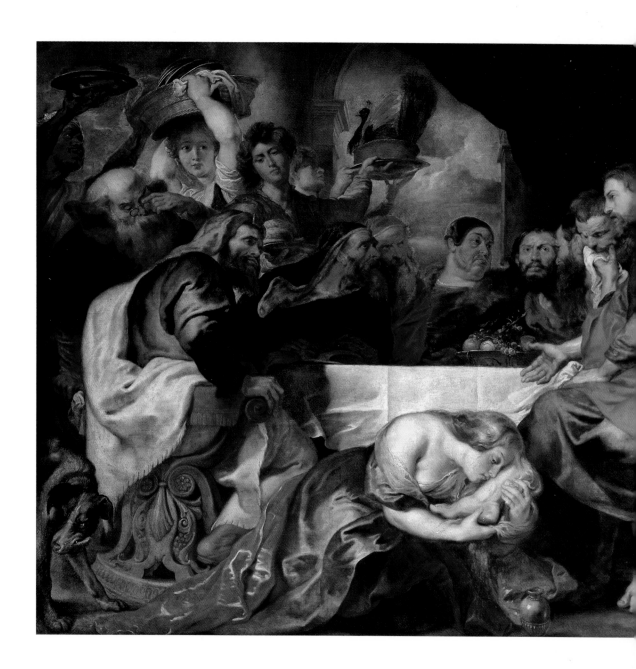

Feast in the House of Simon the Pharisee

Peter Paul Rubens. Flanders. Circa 1618

The Gospel of St Luke that describes the feast in the house of Simon the Pharisee makes no mention
of a dog. But in Rubens's work there is no chance detail, no superfluous personage. The dog furiously
gnawing at a bone is placed in the lower left-hand part of the composition. What does that imply?
Simon, a member of a strict Jewish sect, became interested in the teachings of Jesus, who spoke to the people
of Israel about a new covenant with God, and invited him home for a meal. Among the others that came was
a woman known to the whole town as a great sinner. During the meal and the conversation she washed
Christ's bare feet with tears of repentance and rubbed them with myrrh – a very expensive aromatic oil,
with pain-killing properties. Christ said to the woman: "Your sins are forgiven... Your faith has saved you..."
His dining companions were indignant. Imagining themselves to be free of sin, the Pharisees angrily
demanded that the woman should receive her just deserts in accordance with the customary
Old Testament laws.
The artist has depicted the dramatic moment when the dispute around the table has escalated
into a furious confrontation between the supporters of the old and new ways. Under the old law people could
expect inevitable retribution for their errors: "an eye for an eye". Under the new covenant they gained
the hope of God's mercy and forgiveness, if their repentance was sincere. The dog, like his master,
is on the side of the zealots of the old ways, According to an unwritten rule, time in a picture "moves"
from the bottom left-hand corner (the "past") to the top right (the "future"). And so the dog is shown
to be in sympathy with the past. It becomes a visual embodiment of hatred and cruelty, a symbol
of the basest aspects of human nature.

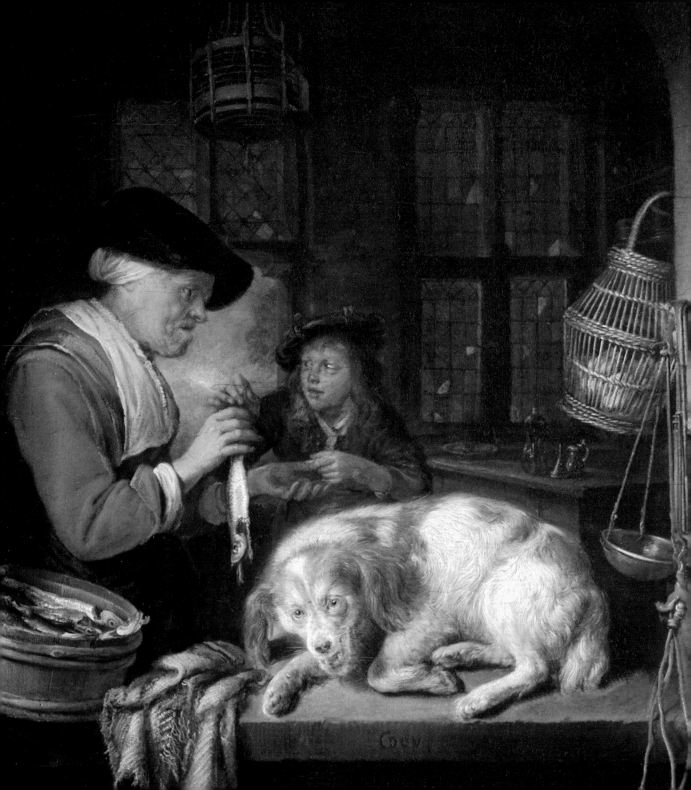

The Herring Seller

Gerard Dou

Holland. Circa 1670–75

The old, unattractive bad-tempered dog has lain down on the sill of a niche-like window,
but clearly has no intention of sleeping. Its bloodshot weak-sighted eyes keep a constant
vigilant watch on anyone who might pose a threat to the wealth it is guarding. The dog resembles
its aged mistress and its entire appearance projects traits of character that are hers as well:
distrust and miserliness. The artist has arranged the composition and the lighting in such
a way that it is the image of the dog that primarily catches our attention.
The niche motif was often used in still lifes of this period. In this sacrosanct space apart artists
would place objects in a combination that had deep philosophical meaning: an hourglass,
a skull, a candle, a bouquet of flowers, and the like. Here, though, as if parodying wise reflections
on the vanity of earthly things and the sublimity of heaven,
the niche is the setting for commerce.

Breakfast

Gabriel Metsu. Holland. Circa 1660

Oyster Eaters

Frans van Mieris the Elder. Holland. 1659

The smartly dressed gentleman bows slightly to the young lady as he offers her an expensive delicacy –
oysters on a silver dish. She regards him with calm dignity. In the art of the day oysters were often used
to imply an unambiguous suggestion to become much better acquainted. They suggested seduction,
even a proposition.
Neither the woman's pose nor the expression on her face permits us to say for certain what her response
will be to the gentleman's offer. But her pet knows. An old Dutch saying tells us that "As the mistress,
so her dog." And the dog sitting by our heroine, the embodiment of vigilance, does not betray the slightest
anxiety. Evidently it is certain of its mistress's moral principles: the oysters will be declined.

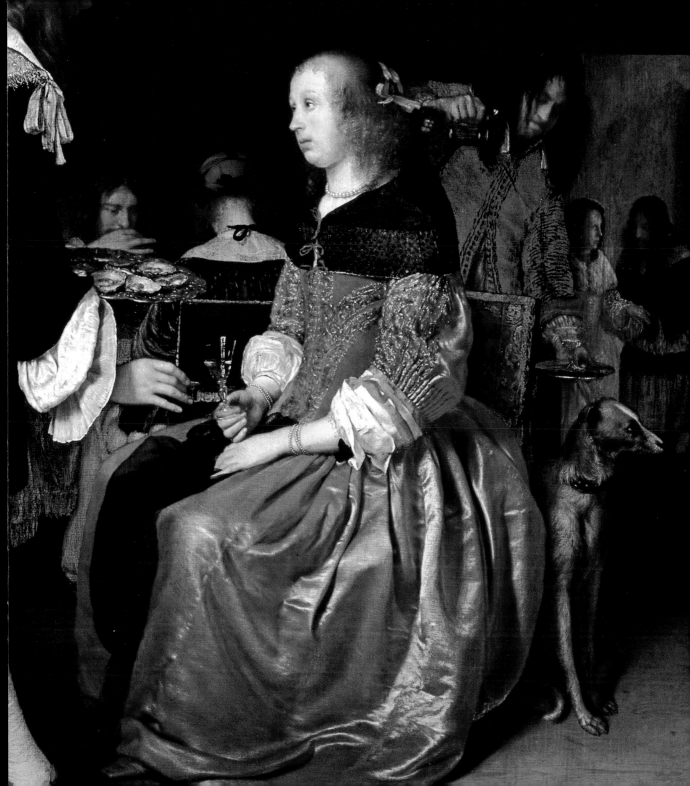

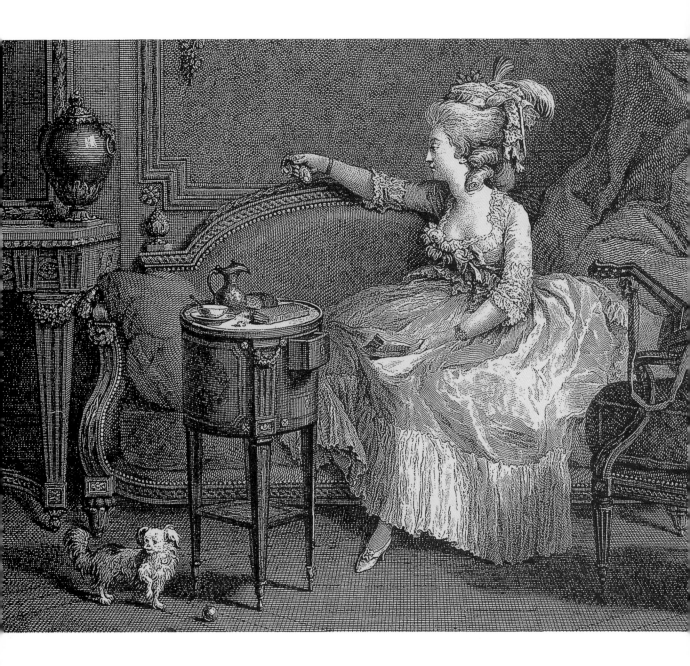

Consolation in His Absence

Nicolas de Launay. 1785

The finely dressed young lady is bored and pining. On the wall above her head is a depiction of the cunning Cupid, whose arrows of love are the cause of her sufferings. The lady is aching for the return of her suitor. Neither music, nor reading can distract her. In her hands she holds the letter that has been read time and again, and a keepsake, probably from her beloved. Her only consolation in her loneliness is the devoted little toy dog that bears a great resemblance to its mistress. Its wavy, carefully groomed coat looks like the lady's fanciful coiffure and the lace and frills of her dress. Something has distracted the dog from its game with the ball; it is listening carefully for something. Perhaps its keen canine hearing has detected distant footsteps that herald the long-awaited suitor.

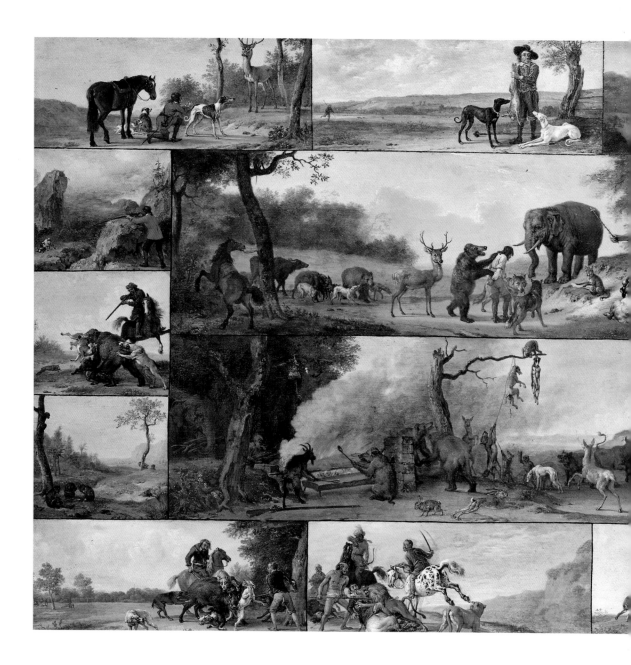

Punishment of a Hunter

Paulus Potter. Holland. Circa 1647

This painting consists of twelve separate little scenes and two larger ones in the centre
that represent the finale of the story and reveal the meaning of the overall title. It "reads"
like an edifying tale. At the top, between scenes from Christian and ancient mythology,
Potter has placed a portrait of a contemporary hunter with his two hounds. Then follow left
and right depictions of the "hero's" many hunting feats and the most incredible "tall tales"
from which he always emerges victorious. If only the huntsman knew how the victims
of his cruel amusements feel!
The artist gives him the opportunity: in the central scenes The Animals' Trying
the Hunter and The Execution of the Hunter and His Dogs vengeance catches up with him.
The hounds – the hunter's loyal servants and accessories – are sentenced by the court
of beasts presided over by the lion to share their master's fate as traitors to "animal-kind".
Potter's painting is an example, rare for the seventeenth century, of "the world turned upside-
down", a reverse allegory. In the European tradition this technique is a means for a person
to reflect on his life. In this case the essence of the reverse allegory lies not in the fact that
the animals act as or parody humans (as judge, jury and executioners), but that humans
see in them a reflection of their individual and social vices and the inevitable
punishment that follows.

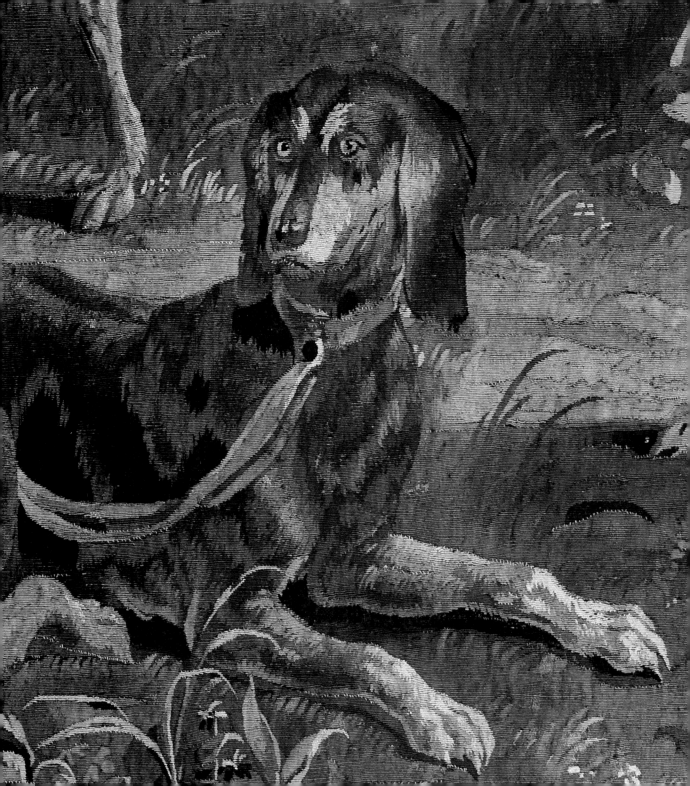

DOGS IN SERVICE

The things dogs have learnt for the sake of humans! The number of jobs they have mastered! They guard people's homes and families; they track and retrieve game; they guard and drive herds and flocks; they pull loads, act as guides and provide aid. To save people they plunge into fire and water, to amuse them they perform in circuses and on racetracks.

People have exploited dogs' natural talents – their keen senses of smell and hearing, their intelligence and physical abilities. "There is no other animal," the Austrian animal psychologist Konrad Lorenz asserted, "that has so radically changed all its way of life, all its sphere of interests, become so domesticated, as the dog."

Some of the "professions" that dogs have acquired over many years of service and friendship have become obsolete today; others remain vitally important to humans.

Let us begin with the most ancient.

A Hunting Dog
Tapestry: *The Triumph of Diana*
Flanders. 1717–34. Detail

Mlle Lenormand Fortune-Telling Cards
Austria. Late 19th century

A "Hunting Map"
Reverse. Germany. Late 19th century

Boxers in the Ring
Back of a playing card
England. Early 20th century

GUARD DOGS

The ancient humans who tamed dogs or wolves exploited one of the basic instincts of any wild predator – to guard its territory. After making friends with the dog, humans invited it to guard territory – theirs. Since that time many an intruder, four-legged or two-legged, has encountered a serious obstacle.

Cave camen! ("Beware of the dog!"). Warning signs like that already appeared on the gates of Ancient Roman villas.

Dogs guarded humans from theft and violence not only at home, but also on journeys. When setting off, travellers going on foot quite often tied their purses to the collar of their dog – from where no-one would dare to take it.

From deep antiquity canines also stood on guard at city gates. There is a well-known Greek legend from the time of the Corinthian War (395–387 BC) about dogs that saved Corinth from

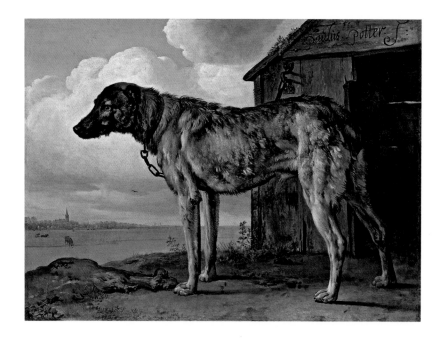

Bandog
Paulus Potter. Holland
1653–54

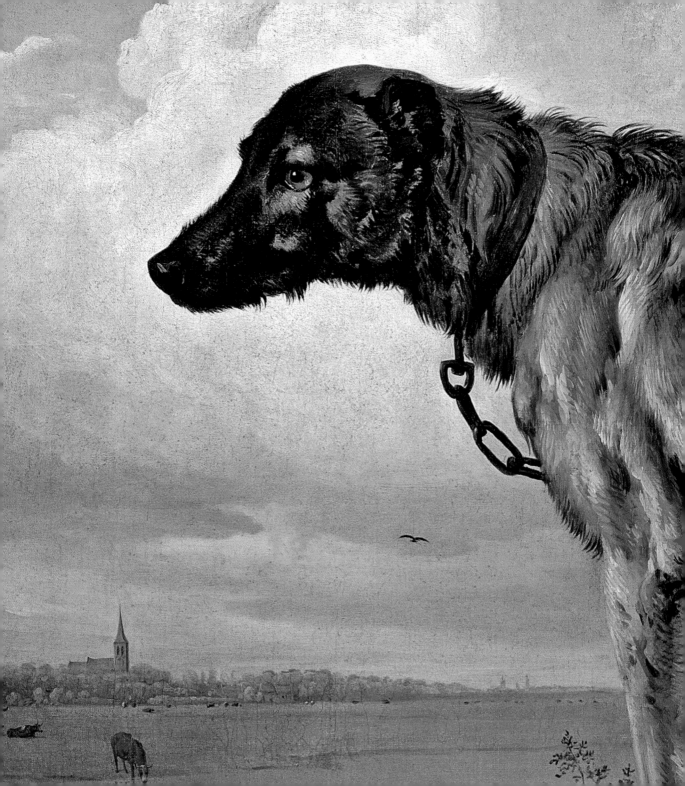

its enemies. It is said that one night, when the city's internal garrison was sleeping peacefully, the Spartans tried to sneak into the city. But fifty guard dogs barred the intruders' way. The barking and noise of the melee awoke the warriors, but, by the time they entered the fray, only one dog, named Soter, was still alive. The Spartans were defeated, the city saved and Soter was given an award for his loyalty and bravery: a silver collar inscribed "Soter, defender and preserver of Corinth". A marble monument was supposedly also erected in his honour.

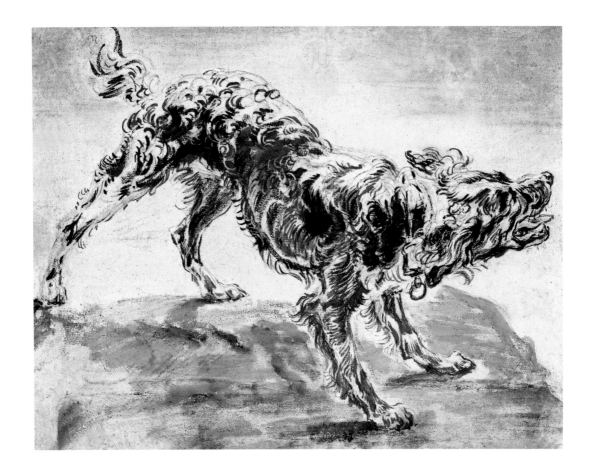

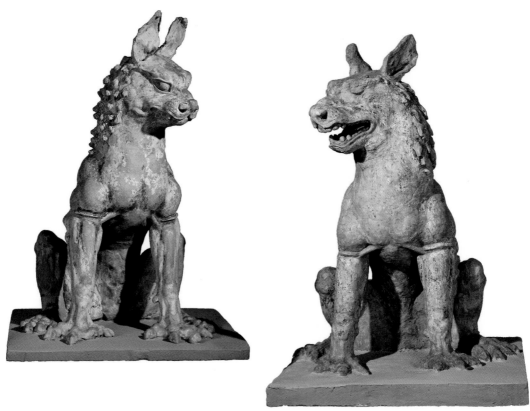

◄ Dog

Jan Veith. Flanders. 1640s

Mythical beings with dogs' heads

Mogao cave complex (the Cave of a Thousand Buddhas), Dunhuang
China. 9th century

In China and Japan it was customary to place statues of fantastic animals by the entrance to temples,
palaces and tombs. Sometimes they took the form of dogs with lions' heads, sometimes creatures with dogs'
heads. In China these guardians of the gate were known as shishi or Fu dogs, in Japan as shishi or koma-inu.
The stone guardians did not prevent people from entering: they served as a magic barrier to evil spirits.
They were usually placed in pairs, one on either side of the entrance.
A guardian with an open snarling mouth scared off demons, one with a closed mouth "hid"
good spirits to keep them from harm.

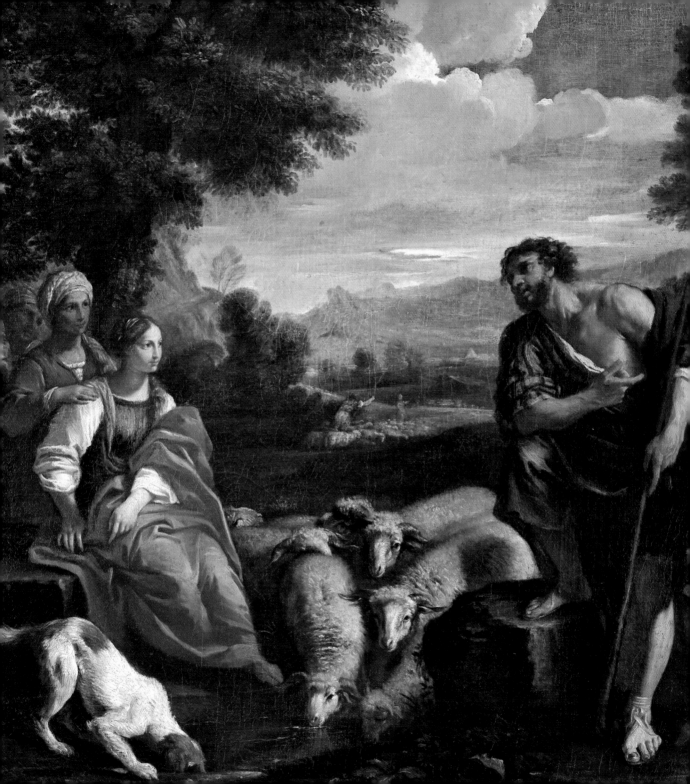

HERDING DOGS

When humans managed to tame other wild animals, they acquired domesticated sheep, cattle and goats. And they needed help. It is quite possible to manage two or three sheep or a couple of cows on your own, but what if the herd or flock is larger? Wild animals might take all the livestock, if nothing warns the herdsman of their approach. Without dogs the ancient herders would have had a hard time. The most common domesticated herd animals in the Ancient World were sheep. They were looked after by shepherds. And so the dogs that helped these humans became known as sheepdogs (or even just shepherds), irrespective of their actual breed.

Herding dogs have a distinctive character and skills. They need to understand their master well and to precisely carry out his instructions, while being wary of strangers and never, ever obeying them. They need to keep careful watch that the herd does not scatter, while not being aggressive towards the livestock. They have to have an excellent sense of smell, so as to detect enemies at a distance even at night. They need to drive predators away from the herd, without going chasing after them, or else their charges will be left unprotected. For the same reason herding dogs are trained not to pay attention to "extraneous game" – hares, rabbits and squirrels – however much they might want to chase them, because all dogs have very strong instincts. This all required special nurturing and training.

Appearance also had significance. Most often animals with white or light-coloured fur were chosen as herding dogs, because they could immediately be told apart from grey wolves.

Gradually, as civilization advance, there were fewer and fewer predators in developed countries and the main job of herding dogs was not so much to guard as to control the livestock. Dogs were taught to drive the animals from one pasture to another, avoiding cultivated fields, to turn the herd in the required direction, to find and bring back animals that had strayed without frightening them. And they had to be especially careful when dealing with the young –

Jacob Meeting Rachel
Pier Francesco Mola. Italy. Circa 1659. Detail

In order to obtain Rachel's hand in marriage, Jacob had to work for her father for seven years before their wedding, and then seven years more.

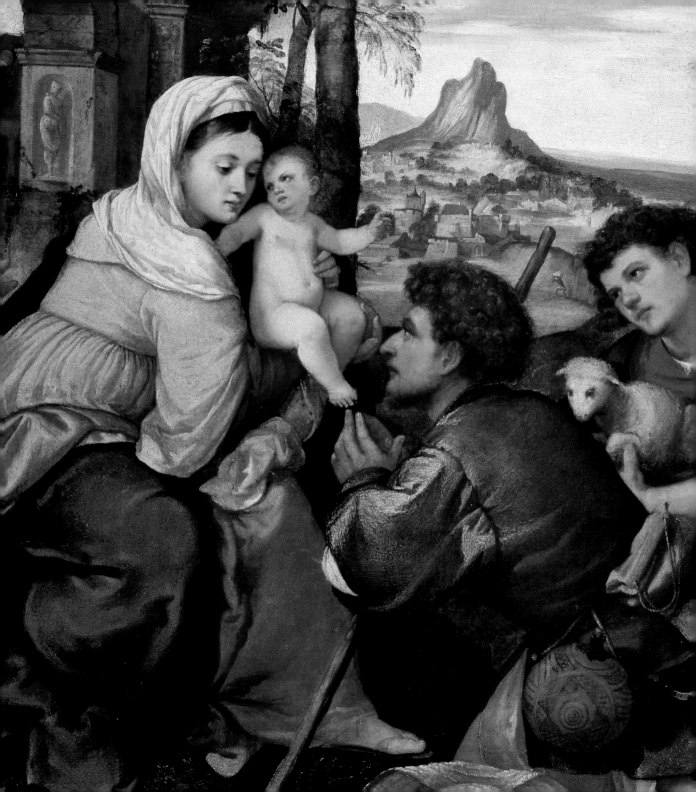

The Adoration of the Shepherds
Bonifacio Veronese. Italy. 1523–25
Detail

Jesus was born not in rich apartments, but in a bare
cave that was usually used to shelter animals in bad weather.
And so the local shepherds were closest of all to the new-born
saviour. When they learnt of the miraculous events from
the angels, they came first to look at the wonderful child
and to worship Him.
They brought their sheep and dogs with them.

adults might be given a slight nip, but the little ones could only be given a prod with the nose. Attitudes to the colouring of herding dogs also changed: in some places the preference was now for dogs with dark coats. They could be seen more easily against the background of the light-coloured herd and it was easier to check whether they were in their proper place and had not been distracted from their duties.

The fame of certain breeds of herding dogs spread far afield. In 1797 Emperor Paul I of Russia gave orders for the purchase from Spain of dogs belonging to a special breed "to which is attributed the ability to keep a herd together and to protect it from predators." In 1803, by which time Alexander I was on the throne, the *Mastini* appeared in Russia – strong, fearless, intelligent dogs with an agreeable character and great sensitivity.

A properly trained herding dog could display some truly phenomenal talents. It proved capable of separating a given quantity of animals from the herd – twenty, say – and drive them wherever indicated (such as a watering place, a different pasture or the market)!

Landscape with a Shepherd and Flock
David Teniers the Younger
Flanders. Mid-1640s

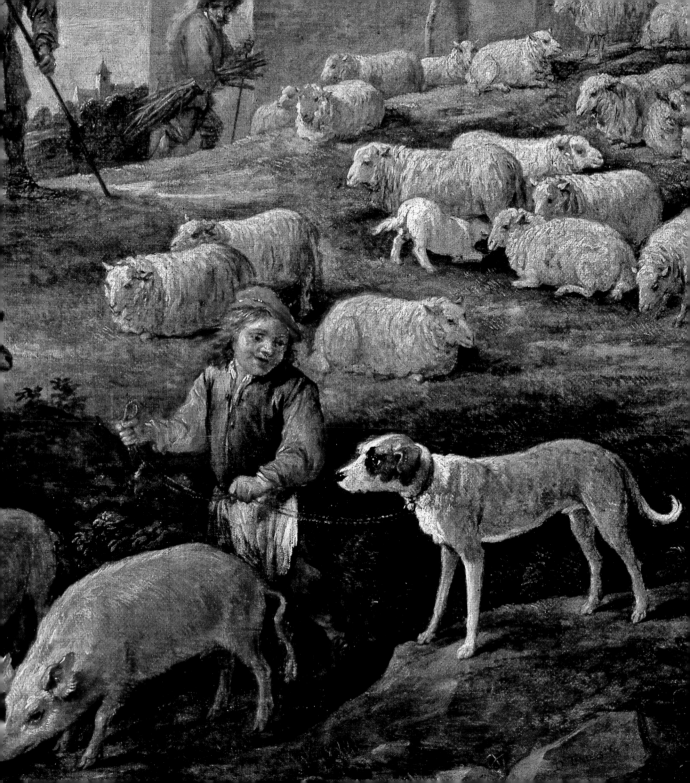

Shepherd Boy with a Dog

Bertel Thorvaldsen. Denmark
After 1817.

On the Way to Market

Constant Troyon. France. 1859
Detail

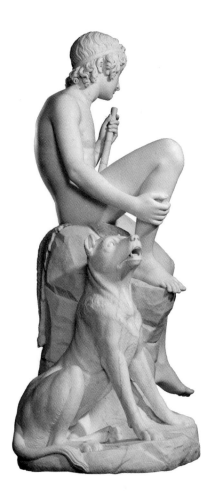

HUNTING DOGS

Humans began hunting with dogs a very long time ago. Originally hunting was a vital necessity for human beings, a means of obtaining sustenance. And the help of dogs was very opportune: canines had quick legs, formidable jaws, a strong sense of smell and very sensitive hearing – sixteen times as keen as people's! Their joint efforts produced an incomparably better result.

Later hunting turned into an amusement for the social elite. From Ancient Egypt in the years 2500–2000 BC we have images of the royal hunt and hounds chasing prey. Excavations at the palace of the Assyrian king Ashurbanipal turned up a bas-relief showing hunting and dogs driving wild horses and asses. King Cyrus, who ruled Persia in the years 558–530 BC, spent the taxes from four large towns on the upkeep of his hunting kennels.

The Ancient Greeks also used dogs for hunting. The world's first special piece of research in this field was carried out by Xenophon, who ruled almost two and a half millennia ago. His treatise *Cynegeticus or On Hunting* includes descriptions of the breeds of dog known to the Greeks, the rules for taking care of them and methods of training.

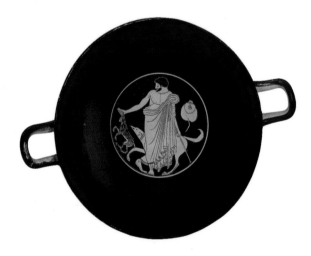

Hare Hunting
Kylix
Ancient Greece. Circa 515 BC

A kylix was a drinking-cup for wine with a shallow bowl on a stem and two handles at the sides. The bottom of this vessel has been painted: black lacquer covers the background, while the figures have been left terracotta red, the colour of the fired clay.

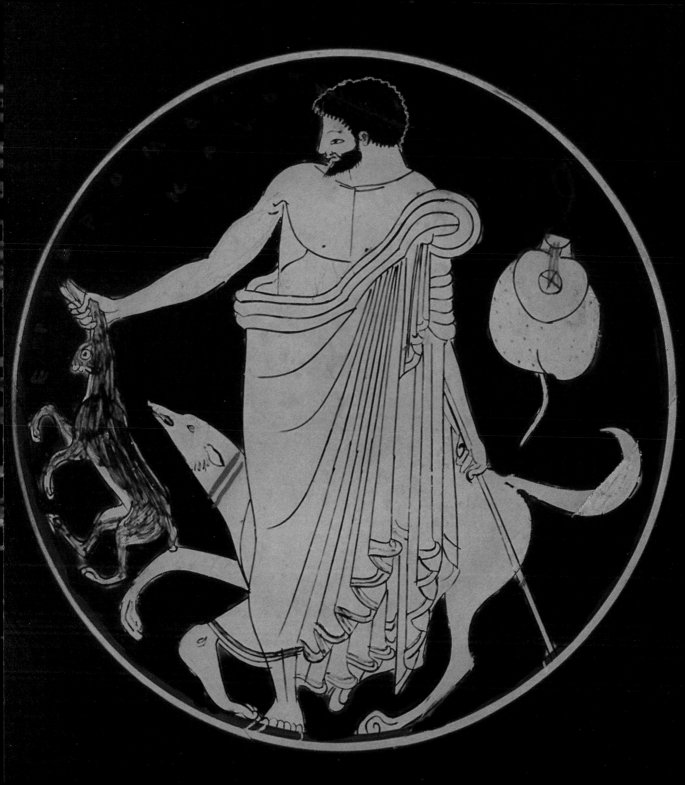

Stag Hunting
Buckle. Iran. 2nd–3rd century

Reverse of a bronze mirror with a hunting scene ►
Central Asia. 10th century
Detail

In his Georgics the Ancient Roman poet Virgil wrote that the Trojans had made a "high art" of hunting with hounds. Their dogs had such great endurance that they could course a stag to its death.

The Greeks' northern neighbours were also keen hunters according to Herodotus: "after spotting a beast from the top of a tree, they loosed an arrow into it, and then, leaping onto their horse, chased their prey with the aid of dogs."

Hounds were also used in hunting by the Thracians, Vikings, Celts, Scythians and Franks.

In the Middle Ages hunting with hounds was a favourite pastime for European feudal lords. In France it reached a zenith of pomp and splendour in the reign (1643–1715) of Louis XIV, who liked to do everything in a big way. Huge packs of hounds (sometime up to a thousand animals) pursued the quarry. Behind them a whole cavalcade of hunters followed on horseback. Occasionally a hunt went on for several days; at times even continuing through the night, when hundreds of servants lit torches.

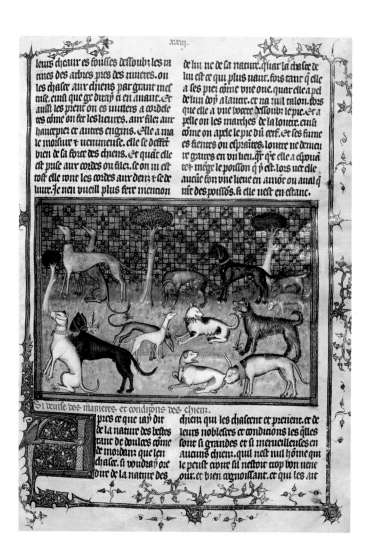

Hunting dogs of various breeds

The Master of Avignon

From Gaston III de Fois's *Livre de Chasse (Book of the Hunt)*

France. Late 14th century

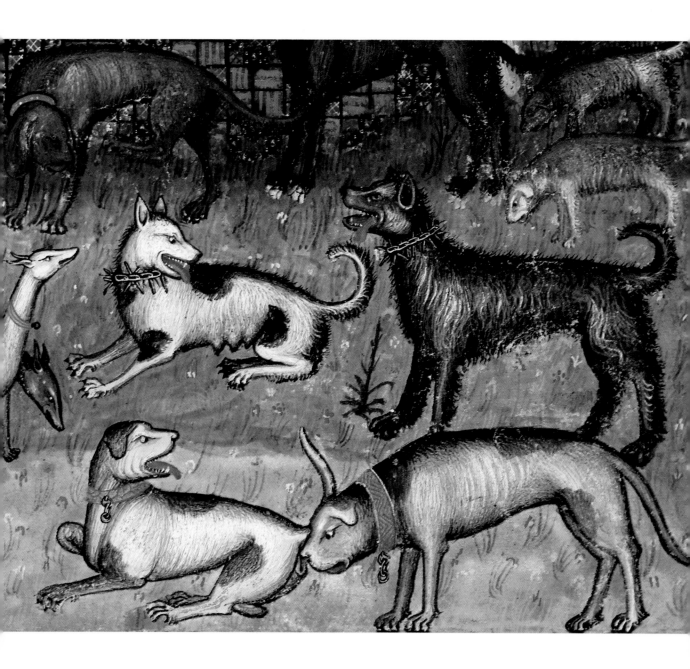

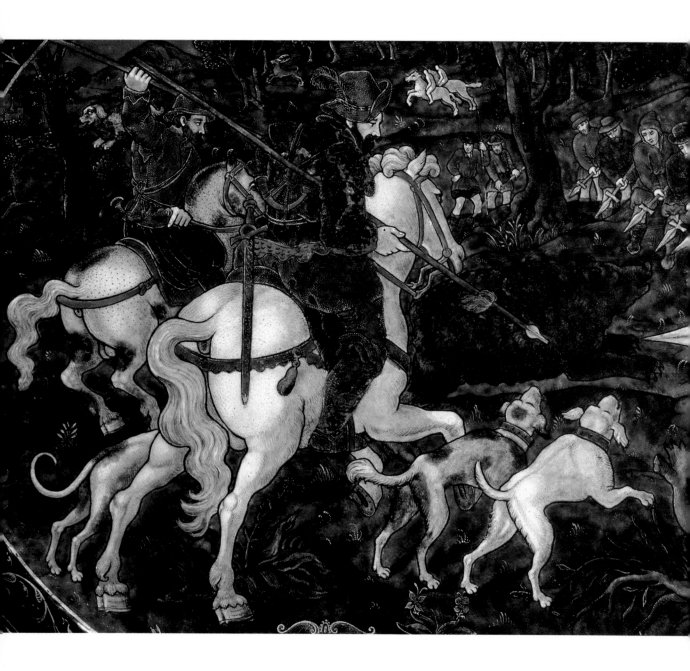

DOGS IN SERVICE. HUNTING DOGS

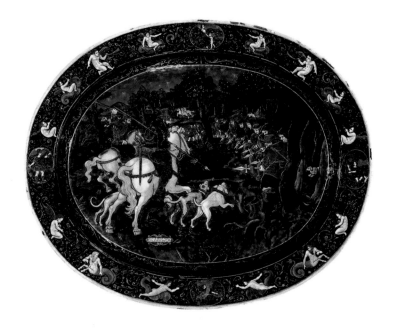

Bear Hunt
Jean Limousin
France. Late 16th – early 17th century

Dog Standing
Unknown sculptor
Germany. 1530s–1550s

Stag Hunt

Tapestry. Flanders. Late 16th century
Detail

Mediaeval tapestries fulfilled the role of both wallpaper and paintings. They were hung on the walls of the huge cold halls of feudal castles. Dramatic scenes of hunting with dogs were frequent subjects for such woven pictures. Tapestries would often share the walls with antlers, boars' heads and other trophies attesting to the courage and valour of the master of the castle.

A Knight Out Hunting

Aquamanile (water jug). Hungary. 12th century

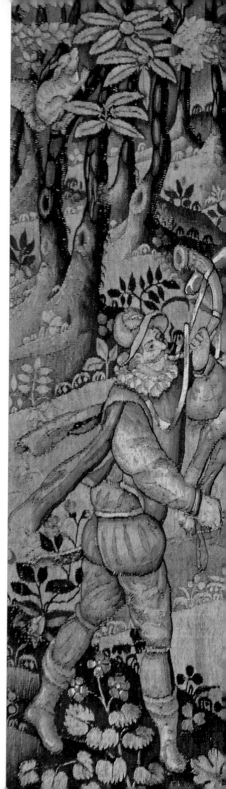

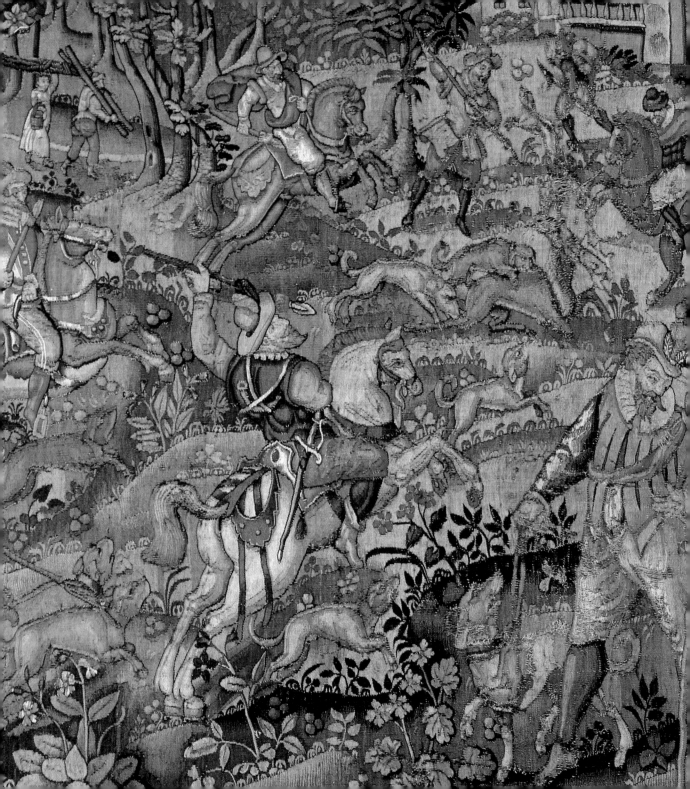

Preceding double page

A Large Hunt

Jacques Callot. France. 1626–28
Detail

*In the seventeenth century France held first place for the number
of different breeds of hunting dogs it produced. Particularly fine were
the white royal dogs that coupled strength and intelligence with elegance.
When hunting in packs they were unrivalled.*

**Napoleon I Hunting
in the Forest of Fontainebleau in 1807**

François Flameng. France. Circa 1899
Detail

*The old woodlands around Fontainebleau were a favourite hunting
ground for the French rulers since the twelfth century. The royal retinue
came there each year for the autumn hunt, when the suburban chateau
was in decline and when it prospered. It would seem that even after
eight centuries the Forest of Fontainebleau contained enough animals
not to disappoint hunters.*

A Hunting Dog

Pierre Jules Mène
France. Mid-19th century

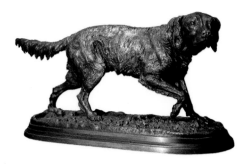

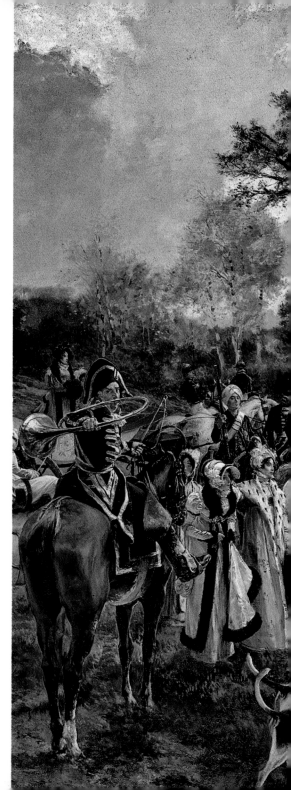

FRANÇOIS·FLAMENG

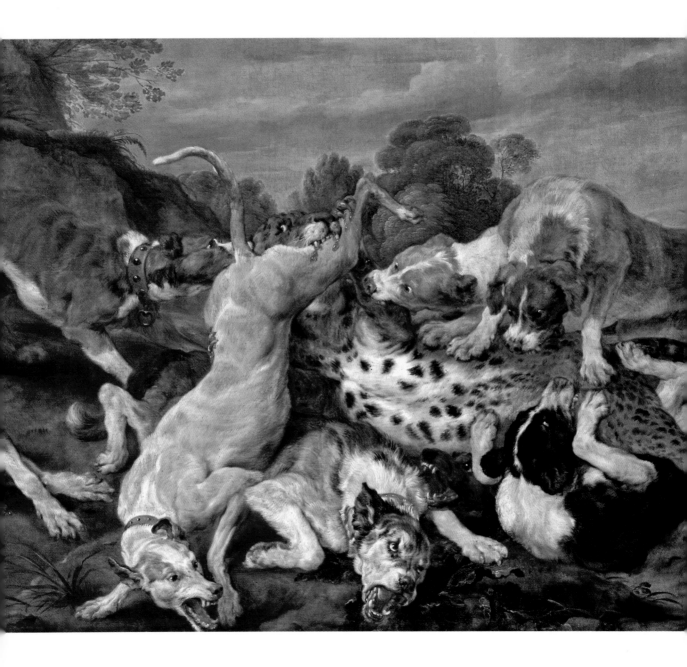

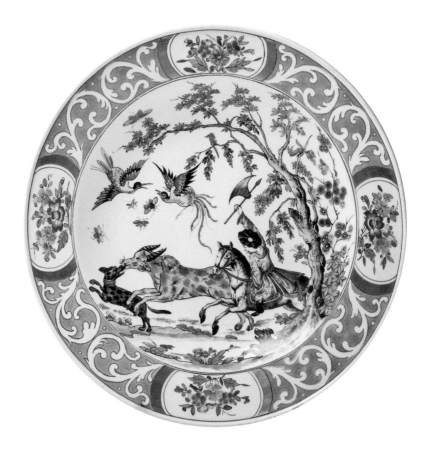

A Leopard Hunt

Pauwel de Vos, Jan Wildens

Flanders. 1630s. Detail

A fascination with exotic subjects and the depiction of rarities (which leopards certainly were in Flanders) was characteristic of the period and European artists had to pay tribute to the fashion.

Out Hunting

Dish. Meissen Porcelain Factory, Germany

Circa 1730–35

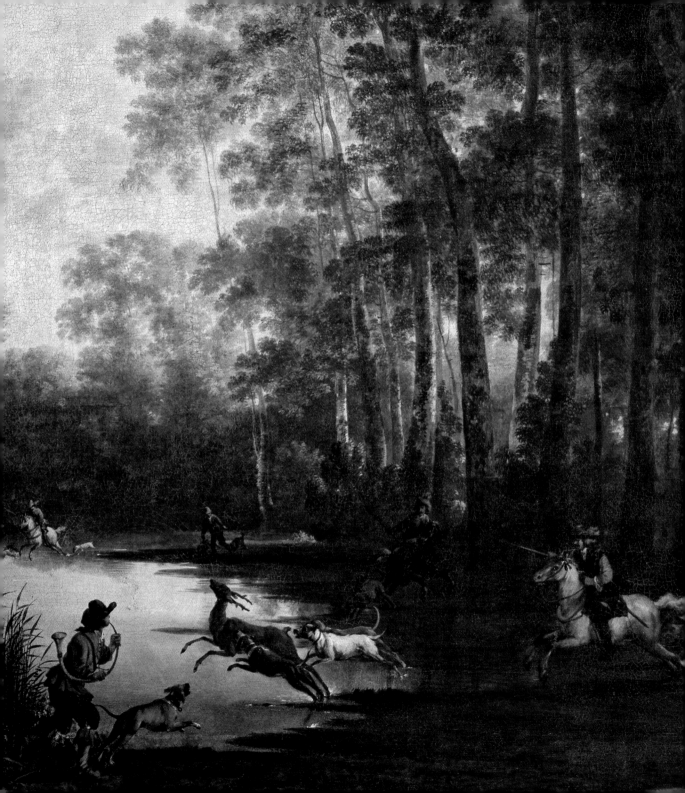

◄ Deer Hunt

Johannes Hackert, Johannes Lingelbach
Holland. 1660–70
Detail

This picture presents the final episode of the hunt: the exhausted deer have nowhere left to go.
The huntsman in the foreground is sounding a large horn informing the hunters that the chase has ended.
The signals made with the hunting horn were well understood by both humans and dogs.

Autumn

Pieter Snyders
Flanders. 1730s
Detail

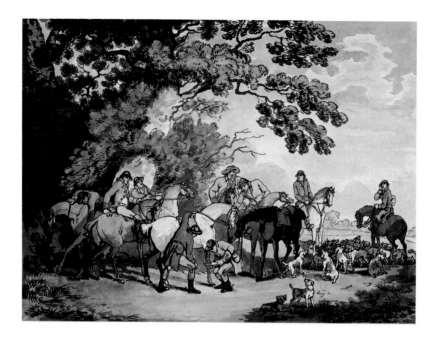

**Going Out Hunting
in the Morning**
Thomas Rowlandson
Britain. 1786

In the British Isles wolf-hunting was popular. Since the time of the ancient Celts, a special breed existed that we now know as the Irish Wolfhound – a huge animal, reaching 120 centimetres at the shoulder and capable of dealing on its own with any creature.

In 1210 King John of England presented Llywellyn, the independent Prince of Wales, with a wolfhound that was given the name Gelert. Once Llywellyn returned home from hunting to find Gelert with his jaws all in blood, his son's cradle overturned and the boy himself missing. Thinking that the dog had turned on the child he was meant to guard, the furious Prince drew his sword and killed his hound. It was only then that he heard the babble of his son, who had crawled into a corner, and noticed the carcass of the wolf that Gelert had killed, saving the boy. Llywellyn was overcome with remorse. On his orders a monument was erected on the wolfhound's grave.

When the hunters and their hounds had exterminated all large predators in England, the fox became the focus of most hunting for pleasure. After the early eighteenth century, when

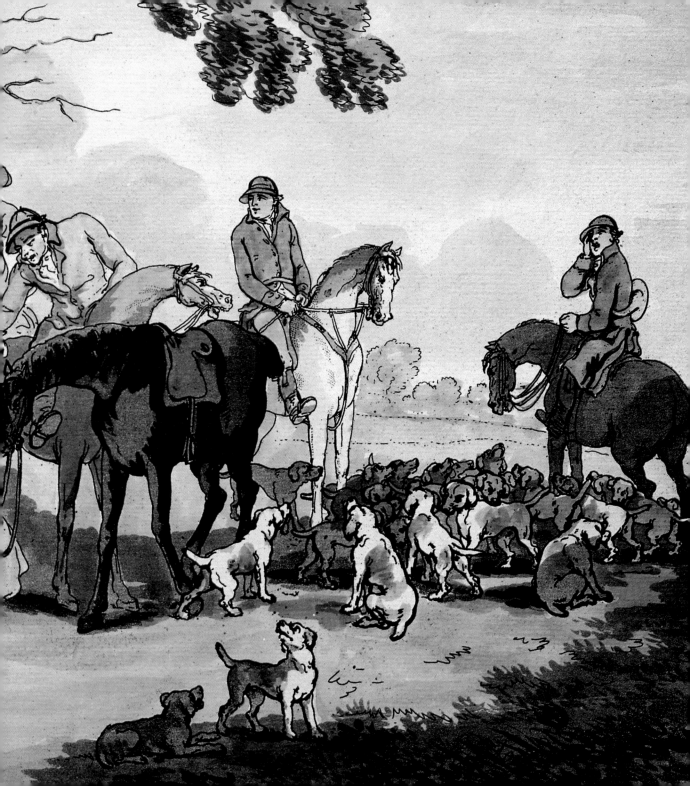

Hunting Dog
Intaglia
Charles Brown. Britain. 1793

Dogs and a Magpie
John Wootton. Britain. 1740s
Detail

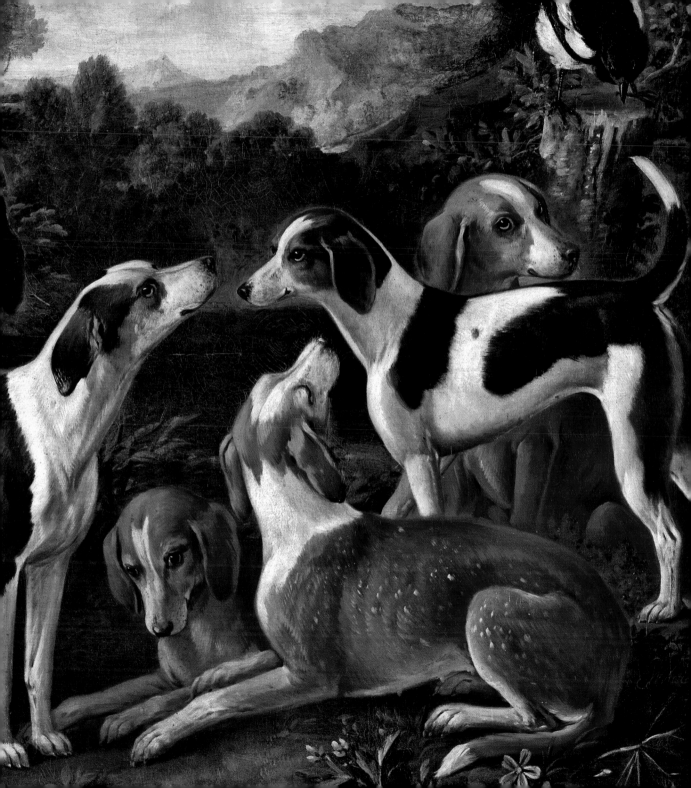

King George I permitted not just aristocrats, but also farmers and the middle class to join in the pursuit, as long as they wore the traditional fox-hunter's pink coat (actually scarlet), this type of hunting became exceptional popular. On the day the season began, all matters were postponed – even parliament emptied.

More recently, out of humane and other considerations, the British started to organize drag hunts in which the hounds follow a trail deliberately laid by someone dragging a bag scented with aniseed oil or possibly fox urine. In this way the hunt turned into something like a sporting competition, or mass outdoor exercise – riding to hounds. A prize might go to the hound that reaches the end of the trail first. Still all the male humans participating are expected to wear the traditional hunting pink.

Hare Coursing
Stevengraph woven silk picture
Britain. 1878–86

Dog
Painted decoration of a dish
Meissen Porcelain Factory, Germany
Circa 1730–35
Detail

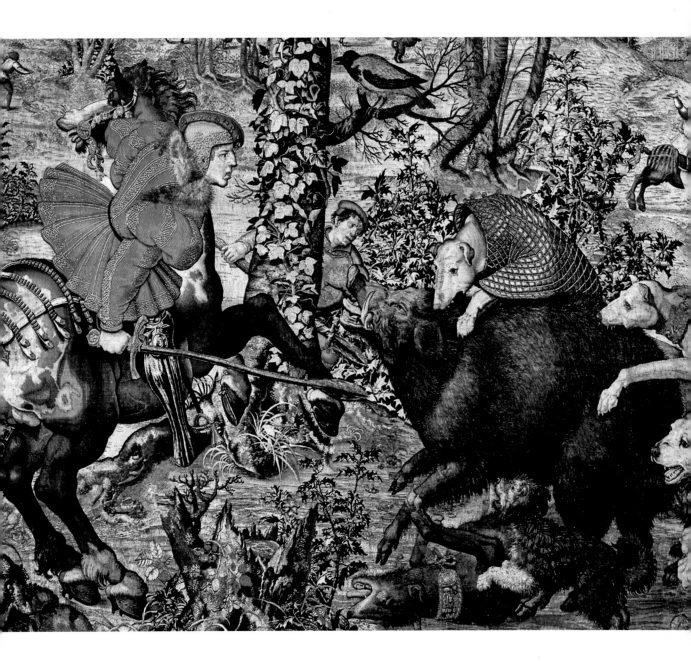

In Germany cross-country boar-hunting was popular with the elite: hounds would pursue a beast until its strength failed and it was brought to bay, then the hunters would move in to finish it off. In order to protect them from the boar's tusks, the hounds were dressed in special padded leather capes and their necks were shielded by a broad thick leather collar.

Hunting with hounds had an important place in German culture and sometimes even military operations were suspended for the sake of it, like in Ancient Greece during the Olympic Games.

Historical accounts survive of a hunt near the town of Nidda, held on 23 October 1633, at the height of the Thirty Years' War. The two landgraves who took part – Wilhelm of Hesse-Kassel and Georg of Hesse-Darmstadt – were on opposing sides. This significant event found reflection in a book of hunting sketches by the artist Valentin Wagner (1610–1655). During the hunt the 20 hunters and numerous beaters, huntsmen and dog handlers ate 164 measures of butter, 400 chickens and 167 cheeses, washing the food down with 180 litres of wine. When the glorious sport was over, military hostilities were resumed.

Emperor Maximilian Hunting
After a cartoon by Bernaert (Barend) van Orley
Tapestry. Netherlands. 1530s

Fallow Deer and Dogs
Meissen Porcelain Factory, Germany.
1760

Boar Hunt

Jan Pieter van Bredael the Younger
Flanders. 1711. Detail

*The finale of a hunt often turned into a spectacle no less striking than
Ancient Roman circuses. The spectators, mostly noblewomen, have taken
places with every comfort and in perfect safety on an enclosed stand
beneath a cloth awning. The artificial scene is contained by canvas
walls. Drivers have used their dogs to gather the prey in here – deer and
boars. The audience is watching the last act of the performance:
the hunters and their assistants using knives and spears to finish off
the animals. Alas, the times had passed, when a hunter would enter into
dangerous single combat with a wild beast in its natural environment.*

Items from a Hunting Service

Meissen Porcelain Factory, Germany
Circa 1765

*It was customary to roast hunting trophies at once. The party feasted
in the castle or in large tents directly in a clearing. In that case special
hunting services were used.*

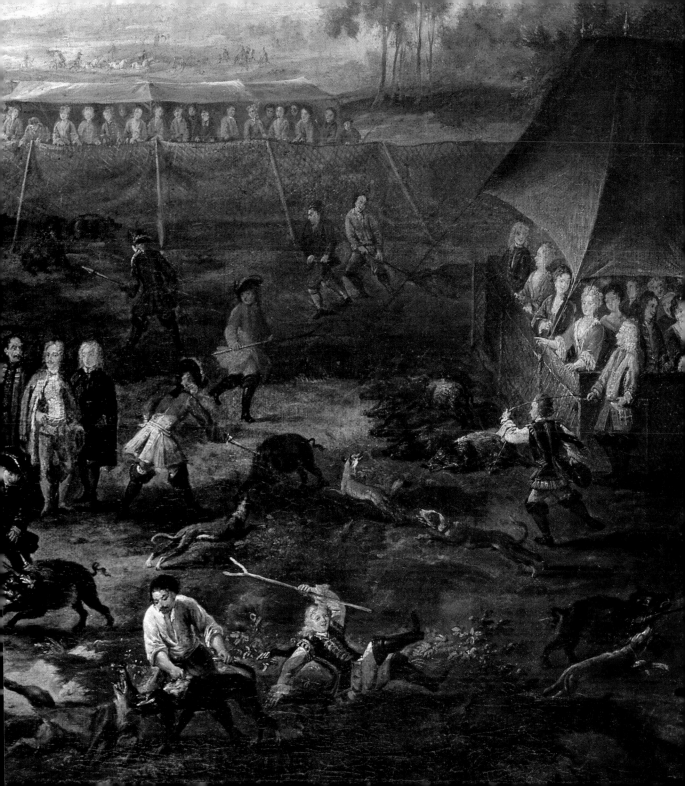

Bark
Nikolai Martynov
Lithograph
after a drawing
Russia. 1850s
Detail

In Russia hunting with dogs was known from early times as both a trade and an amusement. One of the eleventh-century frescoes in St Sophia's Cathedral in Kiev shows hunting dogs. Specialists have indentified three types of dog there: a *catch dog* attacking a boar, a *bay dog* chasing a squirrel up a tree, and a *scent hound* pursuing a stag.

Hounds are quite possibly the largest group among the hunting dogs. All the breeds of scent hound are descended from ancient catch dogs, with each geographical area – England, Poland, Courland, Russia, and so on – producing its own types. They were in use long before the invention of firearms.

Hounds were used in forests and more open countryside for hunting hares, foxes, boars, wolves, lynx and deer. The hounds had a strong sense of orientation and would drive small prey

into nets. Larger prey would be held at bay until the hunters arrived or actually driven onto a hunter's arrow, spear, sword or knife.

Hounds were prized for such qualities as their nose, intelligence (the ability to find a trail quickly on its own and understanding of where to look for an animal that has taken cover), keenness (speed of pursuit) and stubbornness in pursuing the prey. The main task of a sent hound is to pick up a trail, using its nose, and to keep following it, ignoring the detractions of other scents, and to bring the prey out into the open.

When they find a trail, scent hounds bark to announce the find. And they continue to "give voice" in the course of the pursuit. Their voices are different in timbre and change depending on what animal is being chased. The distinctive "choir" of a pack of hounds is music to the ears of many hunters.

The musicality of hounds has been acknowledged even by professionals. An 1892 article by A. Safronov entitled "The Pack as a Subject for Musical Study" describes the voice of a hound called Budilo in this manner: "His wonderful velvety basso cantante had a range roughly from B flat in the two-line octave…" and so on. It is not for nothing that Russian hounds were often given musical names: Flute, Bassoon, Chord, Bass, Peal of Bells, Little Note.

Gazehounds or sight hounds do not engage in searching for a trail or prey. Their noses are not as keen as those of the scent hounds. They pursue an animal only by sight and only when it moves. Important qualities for a gazehound are *speed of pursuit, endurance, fury* (vital when hunting wolves), *vigilance* (the ability to keep the prey in sight) and *avidity* (the urge to get its teeth into the prey), coupled with a complete lack of interest in domestic animals.

The ancestral homeland of sight hounds is the Asian steppes and African savannah. The Egyptian pharaohs already hunted with such dogs. Sight hounds were usually used for hunting in open countryside, where a hunter could not creep up to within shooting distance of an animal.

The light, impetuous sight hounds got up to such speeds that if they hit some unseen obstacle, such as a tree stump, they could be fatally injured. The old word *borzo* from which the name of the Russian *borzoi* sight hounds comes, meant "swift".

For hunting badgers, racoons and other animals that live in borrows other special breeds were developed – the dachshund and the terriers. They are relatively small in size and can get into a burrow to drive the prey out to where the hunter can shoot it.

People also bred special dogs for hunting birds. When they scented a bird hiding in the grass these dogs will freeze so as not to startle it before the hunter came up – they point by standing (pointers) or crouching (setters). When he sees his dog pointing a hunter shoulders his gun and quietly gives the command for the dog to flush the bird. The hunter has only to pull the trigger. Finding the downed bird among the undergrowth and bringing it back to its master is also the dog's job. When the dog is at a distance commands are given by whistling.

◄ **A Gundog Pointing a Partridge**
Jean-Baptiste Oudry
France. 1725
Detail

Dog and Gamebirds
François Desportes
France. 1711

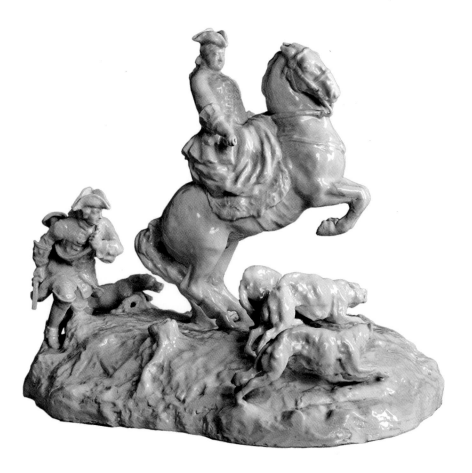

For many years the rulers of Moscow preferred to hunt with hawks and falcons, but in the fifteenth century, the documents indicate, they kept their own packs of hounds. In any case, Ivan III's will of 1504 mentions among other property the Grand Prince's kennels at the village of Lutsinskoye outside Moscow. His son, Vasily III, was a passionate hunter and, according to the historian Nikolai Karamzin, perhaps the first in Russia to make extensive use of dogs for hunting. The German diplomat and traveller Baron Sigismund Herberstein left us a description of one of Grand Prince Vasily's hunts near Mozhaisk: around 300 riders went

◄ Empress Anna Ioannovna Out Hunting
Decorative table ornament (surtout-de-table)
From a model by Konstantin Rausch von Traubenberg
Imperial Porcelain Factory, Russia. 1912

Borzoi Bitch
After a 1874 bronze original by Nikolai Lieberich
Imperial Porcelain Factory, Russia. 1910

*The model was a dog belonging to Grand Duke
Nikolai Nikolayevich*

Vase with Hunting Scenes
Imperial Porcelain Factory, Russia. 1830

*The artists of the Imperial Porcelain Factory often decorated
vases with copies of works by famous artists. For this vase they
used elements from Punishment of a Hunter, a 1647 painting
by the Dutch artist Paulus Potter.*

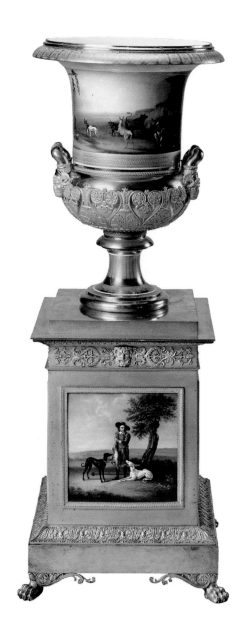

out with scent hounds and sight hounds; whippers-in kept the dogs in packs. The honour of first loosing the hounds was accorded to the foreign envoys and important guests. Then the Grand Prince waved his hands, the huntsmen released the rest of the packs and a general chase after hares began.

Vasily spent even the last days of his life in hunting together with his family: Grand Princess Yelena Glinskaya and their children, including three-year-old Ivan, the future Ivan the Terrible.

Ivan IV Vasilyevich was also keen on hunting with hounds in his youth. In the darker years of his reign he found satisfaction not so much in hunting with dogs as in setting them on people.

Under Mikhail Fiodorovich, the first tsar of the Romanov dynasty, the royal kennels, lost in the Time of Troubles, began their revival. In 1619 he specially sent two hunters and two mounted masters of hounds "to the northern bear country" (Galich, Chukhloma and Kostroma) with

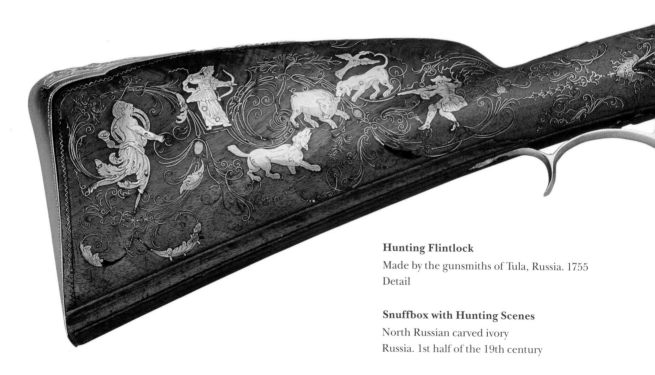

Hunting Flintlock
Made by the gunsmiths of Tula, Russia. 1755
Detail

Snuffbox with Hunting Scenes
North Russian carved ivory
Russia. 1st half of the 19th century

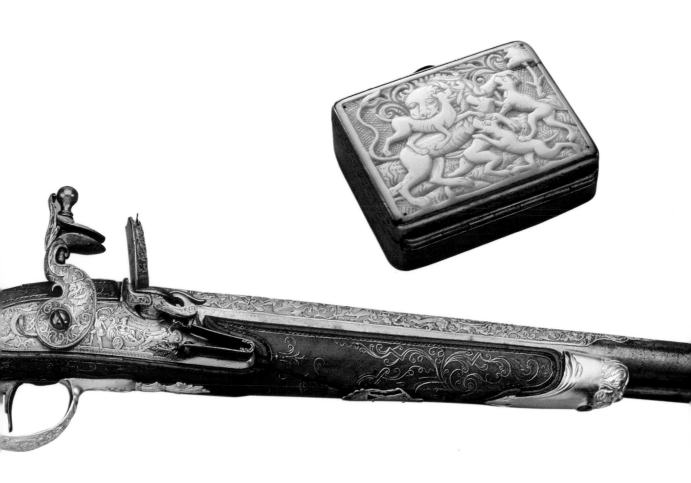

orders to "obtain in those parts from people of any kind sight hounds, scent hounds and catch dogs with large heads and smooth coats, capable of dealing alone with a bear. Hunting dogs were also imported from abroad, the best being chosen for breeding.

A decree that the Tsar issued in 1635 led to Russia's first code of rules relating to hunting with dogs. By the end of Mikhail Fiodorovich's reign, the royal kennels had been given new premises in what were then the outskirts of Moscow, roughly where the Vagankovo Cemetery is

today. They were home to sight and scent hounds, mastiffs, "search dogs", elk hounds, "Britons" (English mastiffs) and dogs "of other fearful breeds", as the inventory puts it.

Their dress leashes were particularly opulent: made of silk, woven with gold and silver threads and embellished with pearls. The collars were made to order by the craftsmen of the Armoury Chamber.

Tsar Alexei Mikhailovich preferred hunting with birds – falcons and gyrfalcons – for swans, ducks and geese. He even personally wrote a book about the rules and secrets of falconry.

His son, Peter the Great, on the whole regarded hunting as frivolous pastime. Once, when he was a youth, the boyars of his retinue persuaded him to go hunting with hounds. Peter ordered the boyars to take the dogs from the whippers-in and to manage them themselves. The hounds quickly got their leashes tangled and dragged many boyars from their horses. The Tsar was openly amused, but then scolded them: "Why have you distracted me from the business of a ruler with dog hunting?" Later, as Andrei Nartov's *Memoirs* report, he was fond of saying: "Chasing after the Swedes is hunting enough!"

Hunting with hounds acquired a new importance and scale in the brief reign of the juvenile Peter II, Peter the Great's grandson. In order to keep the boy from developing an interest in

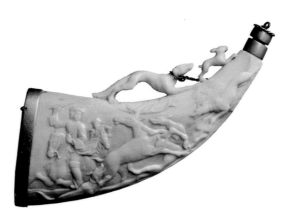

**Powder horn decorated
with hunting scenes**
Russia. 1st half of the 18th century

**"A Gentleman out with an
English sighthound…"**

**"A Hunter who has been out
training young dogs…"**
Timofei Yengalychev. Russia
Watercolours from a picture book
Late 18th century

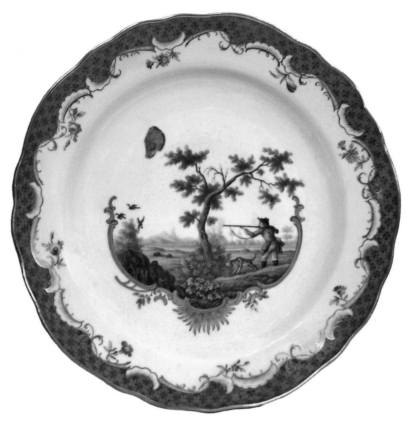

Plates from the Hunting Service
Imperial Porcelain Factory, Russia. 18th century

the affairs of state and interfering in their running of the country, the members of the Supreme Privy Council even attributed a special educational significance to hunting.

In the curriculum and timetable of lessons that they drew up for the 11-year-old monarch we find "afternoons on Tuesday and Thursday – with hounds in the field."

The young Emperor's aunt, Peter's daughter Elizabeth, galloped tirelessly with him across the countryside. And later, when she herself was Empress, she remained a keen huntress and coursed hares across the first snow. Sometimes she would spend days on end in the field, dining in the open air and spending the nights in a special tent.

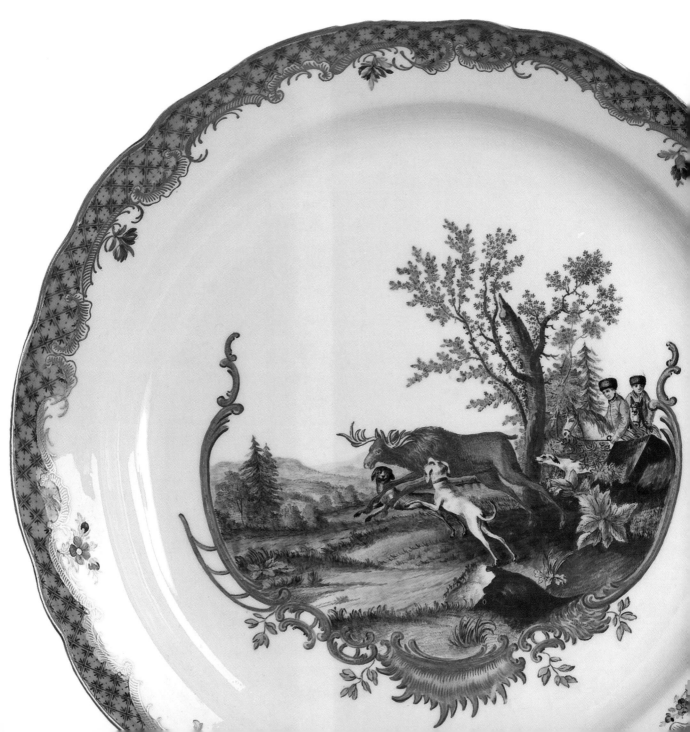

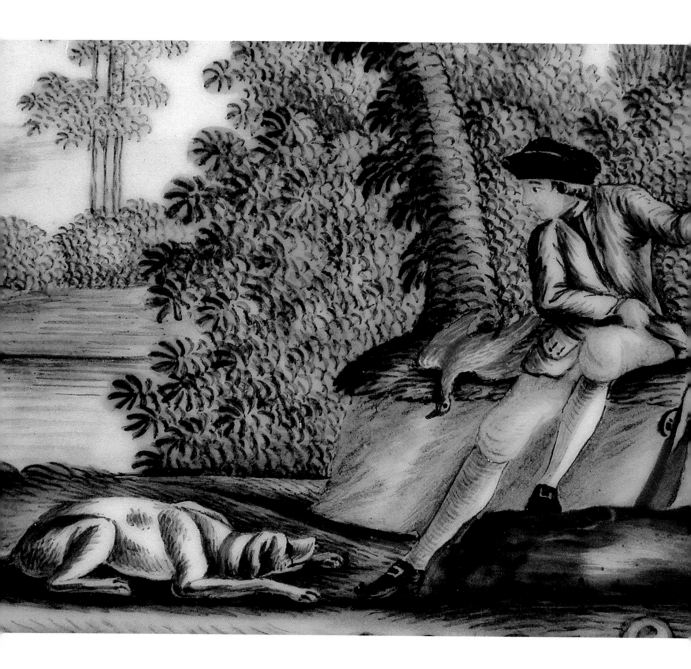

Peter II's hunts were grand spectacles with a large cast and many guests, including "foreign ambassadors and noble Russian persons of both sexes". The Spanish envoy reported to his government: "I presented the Tsar with two gazehounds that had been specially ordered from England and His Majesty was as pleased as if I had given him the greatest treasure." Yet Emperor Peter II's kennels consisted of 200 scent and 420 sight hounds and were constantly being refreshed and enlarged.

It should be said that for centuries hunting had been not just an amusement, but also a diplomatic matter, and sending hounds to friendly rulers was considered a sign of mutual goodwill. There are many examples. When he sent an embassy to Shah Abbas I of Persia in 1600, Boris Godunov included among the gifts a pair of Russian borzois. Catherine the Great, wishing to strengthen relations with King Ferdinand IV of Naples, told Count Razumovsky to send a pack of borzois to Italy. Reporting about his fulfilment of the task, in May 1790, the Count called the hounds "a canine embassy."

Catherine II herself enjoyed duck hunting from an early age. "At Oranienbaum I would rise at three in the morning" and accompanied by a huntsman and a pointer "went off to shoot ducks in the reeds fringing the sea on both sides of the Oranienbaum canal."

Plate from the Hunting Service
Imperial Porcelain Factory, Russia. 18th century
Detail

Catherine II commissioned an enlarged copy of the Meissen Hunting Service from the St Petersburg factory. The Empress presented the new service to Count Grigory Orlov.

An Estate-Owner's Morning
Ye. Potanin. Russia
Watercolour after a 19th-century drawing

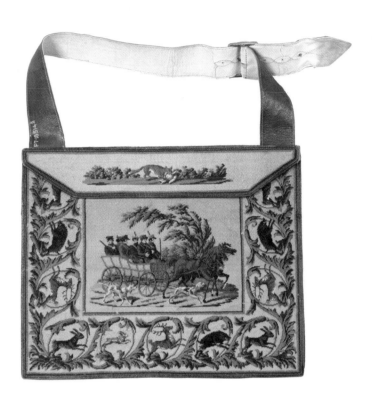

Hunter's gamebag

Russia. 1820s–30s

This leather bag decorated with glass and metal beads belonged
to Emperor Alexander II.

Her grandson, Alexander I, was not fond of hunting, but during the negotiations with Napoleon at Tilsit in 1807, he joined him on a great hunt with hounds – it was, after all, not entertainment, but part of the bargaining process.

Under Emperor Nicholas I hunting with hounds became a part of the life of the court. The imperial kennels, which since Empress Elizabeth's time had been located in St Petersburg, on the Fontanka near the Obukhovo Bridge, were moved in 1828 to Peterhof. The "hunting village" there was designed by the eminent architect Joseph Charlemagne. There were two bathhouses attached to the kennels, one "for the maintenance of due cleanliness and neatness among the people", the other for washing the dogs.

Apart for the hounds on the "staff" of the imperial hunt, the hunting village was also home to the personal pet dogs of the imperial family. Their upkeep was paid for from the Emperor's private funds. An 1847 inventory lists Hector the Newfoundland and a poodle puppy belonging to Nicholas I, two miniature poodles – pets of Empress Alexandra Fiodorovna and 19 dogs belonging to the heir to the throne, Alexander Nikolayevich.

From the early nineteenth century hunting with hounds became an almost compulsory pastime and amusement for the landed nobility, as Pushkin described in his humorous poem *Count Nulin*:

> The time has come! They sound the horn.
> The huntsmen dressed in smartest cloth
> Have been in the saddle from early morn.
> The hounds are straining to be off...

The historian of Russian hunting Leonid Sabaneyev wrote: "Almost every independent landowner, in the provinces around Moscow particularly, felt it a duty to keep borzois and scent hounds, sometimes in considerable numbers – hundreds."

The abolition of serfdom in 1861 marked the end of the Golden Age of hunting with dogs. It became too costly to keep huge packs. Borzois survived only on the estates of the keenest hunters, and the packs people kept for coursing game were now of a small size.

In the late nineteenth century Grand Duke Nikolai Nikolayevich, a grandson of Nicholas I, made an attempt to revive the old Russian tradition of large-scale hunting with hounds. At his estate of Pershino on the River Upa, 30 kilometres from Tula, he created his own hunt, the larg-

The Pointer Captain
Nikolai Martynov
Lithograph
after a drawing
Russia. 1850s
Detail

*The pointer was created by English
dog-breeders in the nineteenth century
and immediately interested their Russian
colleagues. At the First Dog Show
in Moscow a pointer belonging to
the Muscovite breeder Grigory Chertkov
won a Large Silver Medal.*

est in Russia with 140 borzois and 90 scent hounds. A huge team of huntsmen and whippers-in was formed from the local peasantry and retired soldiers of the Life Guards Imperial Hussar Regiment of which Nikolai Nikolayevich was the colonel-in-chief. They oversaw the breeding of the dogs, ensuring the bloodline remained pure, and the observation of the rules of hunting. They also kept studbooks and strict records of pedigree.

The fame of the "world hunting academy", as the Pershino estate was called, spread far and wide. It was visited by both Russians and foreigners. They took to the field in a special railway train and a hunt would last two or three weeks as a rule. Pershino had its own brass band and the musicians were also numbered on the staff of the grand-ducal hunt.

Elderly dogs at Pershino were put on a pension for the rest of their lives. Every one that died was buried in its own separate grave with a cast-iron memorial that, besides the dog's own name, gave its birth and death dates, and the names of its parents.

The outbreak of the First World War in 1914 naturally reduced the scale of the Pershino hunt, and after the October Revolution in 1917 it was finally and permanently liquidated, as they liked to say at that time. Some of the dogs were taken abroad in time, others ended up in the hands of the locals.

The time of large-scale hunting with dogs in Russia had passed.

Baron Vladimir Fredericks Out Hunting
Russia. 1887
Photograph. Detail

Report on the Imperial Hunt for 1896
Rudolf Frenz. Russia
Detail

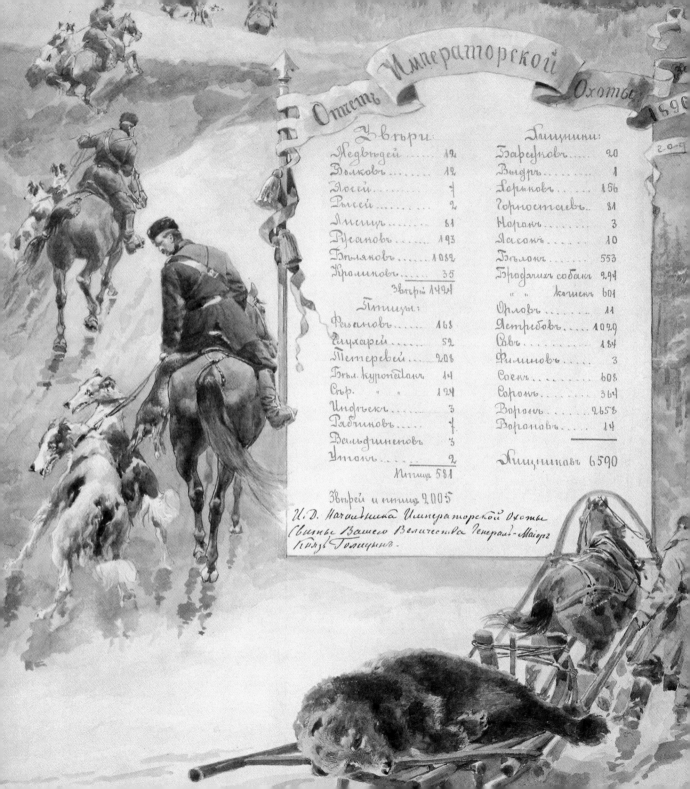

Отчетъ Императорской Охоты 1896

Звѣри:

Медвѣдей	12
Волковъ	12
Лосей	7
Рысей	2
Лисицъ	81
Русаковъ	193
Бѣляковъ	1082
Кроликовъ	35

Звѣрей 1424

Птицы:

Фазановъ	168
Глухарей	52
Тетеревей	208
Бѣл. куропатокъ	14
Сѣр. "	124
Индѣекъ	3
Рябчиковъ	7
Вальдшнеповъ	3
Утокъ	2

Птицъ 581

Хищники:

Барсуковъ	20
Выдръ	1
Хорьковъ	156
Горностаевъ	81
Норокъ	3
Ласокъ	10
Бѣлокъ	553
Бродячихъ собакъ	294
" " кошекъ	601
Орловъ	11
Ястребовъ	1049
Совъ	184
Филиновъ	3
Соекъ	608
Сорокъ	364
Воронъ	2658
Вороновъ	14

Хищниковъ 6590

Звѣрей и птицъ 2005

И.Д. Начальника Императорской Охоты
Свиты Вашего Величества Генералъ-Маіоръ
Князь Голицынъ.

DOGS OF WAR

History has known many examples of dogs participating in military actions. The ancient Assyrians already had dogs who were trained especially for war. Later, when they conquered Egypt in 525 BC, the forces of Persian king Cambyses unleashed whole packs of war dogs on the enemy at the battles of Pelusium and Memphis. Dogs also served in the armies of Xerxes (reigned 486–465 BC) and Alexander the Great. In the first century BC the Armenian King Tigranes the Great used dogs in battles against the Romans. The Romans themselves also employed four-legged warriors. We even know what a Roman attacking formation looked like: in the first rank were great dogs dressed in special armour (a bas-relief uncovered during the excavations of Herculaneum shows a dog in a coat made of small metal scales), then came slaves holding them on leashes, and only then the legionnaires. Before battle the Romans would sacrifice a dog to Mars, the god of war.

In the declining years of the Roman Empire canine gladiators appeared. They were taught how to fight in the arena against lions, bulls, elephants, each other and even human beings. But that says less about dogs than about people with their taste for cruel spectacles.

Much later, when King Edward I of England was waging war to bring Scotland under his rule (1296–1306), he used dogs to pursue his opponents. But that was not enough to enable the English to conquer their northern neighbours.

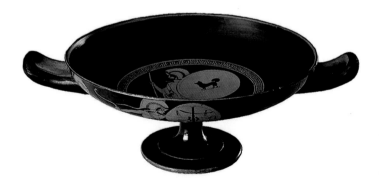

**Depiction of a dog
on a warrior's shield**
The Dokimasia painter
Kylix
Ancient Greece. Circa 480 BC

It is said that Peter the Great's dog, Tyrant, was trained to carry notes with orders on the battlefield and to return with reports.

During the Russian campaign of 1840 in the Caucasus dogs served as the first line of defence. When enemy scouts approached, the animal, which were placed beyond the entrenchments, started barking, warning the human sentries of the uninvited visitors. All the four-legged soldiers received official rations.

In the nineteenth century British dog-handlers worked out special methods of training dogs to find wounded men during battles and to deliver medicines to the front line. In the late nineteenth century German and French army regulations even included sections on the use of specially trained dogs in military operations.

The world wars of the twentieth century forced dogs to master a wide range of military

roles: there were communications dogs that laid telephone cables, medical aid dogs, demolition dogs, canine scouts and dogs that delivered ammunition. In the Soviet Union during the Second World War trained dogs blew up some 300 tanks, found thousands of mines and helped to evacuate 680,000 wounded soldiers from the battlefield.

Towards the end of the war a collie named Dick became particularly famous. This member of the mine-clearance service found a time-bomb that had been left by the retreating Nazi forces in the foundations of the Pavlovsk palace. Later Dick took part in mine detection in Prague. When the time came for him to leave this world, he was buried with military honours.

The Dog Fighters Club
Thomas Rowlandson
Britain. 1816
Detail

The bloody amusements of Ancient Rome were revived in mediaeval England in the form of dog fights. Later the craze spread to France, Spain and Germany. Decent citizens enthusiastically set about producing special breeds of fighting dog. Eventually, however, feelings of shame at such barbaric cruelty grew and this unhealthy entertainment was banned in civilized countries.

Croat Sentry
Louis Gallet. France. 1854

RESCUERS

High in the Swiss Alps, where winter reigns for nine months of the year and blizzards are a regular occurrence, the Monastery of St Bernard stands close to the top of a pass. In the Middle Ages its monks often had to save travellers who had lost their way, been caught by a sudden avalanche or fallen into a crevasse. But finding someone in the mountains during a storm is no easy task, and so in the fourteenth century (by some accounts even earlier), the monks of St Bernard bred themselves canine helpers from the large local guard dogs. Originally they were called "Alpenmastiffs", "saint dogs" and other names, before they became generally known as St Bernards.

These huge dogs, the size of a young calf, are hardy and placid. They orient themselves superbly in the mountains, have an excellent sense of smell and can find a person buried under three metres of snow. With its powerful paws a St Bernard will dig down through the snow, bring an avalanche victim to their senses by licking their face with its tongue and, if necessary, warm them by sharing the heat of their body with its thick coat. Quite often a little barrel of rum or brandy was attached to a rescue dog's collar and a rolled-up blanket to its back – two kinds of immediate aid. Just imagine how many doomed people St Bernards have saved in the course of seven centuries. To search one hectare of territory after an avalanche takes a team of 20 humans at least four hours, a dog can do the same in 30 minutes to an hour. There are record holders among the St Bernards. The famous Barry worked as a mountain rescuer from 1800 to 1812 and in that period he saved 40 lives.

One More Saved
Plate from Eugène Beauharnais's service
Dihl et Guérhard factory, France. 1811–13. Porcelain

On this plate the artist depicted the final episode in a touching tale that had recently moved the whole of Europe. An already elderly rescue dog found a child lying senseless on the edge of an abyss, pulled him to a safe spot and warmed him with his body. The feeble youngster somehow managed to climb onto his rescuer's back and was carried to the door of the monastery. Perhaps the heroic dog was Barry.

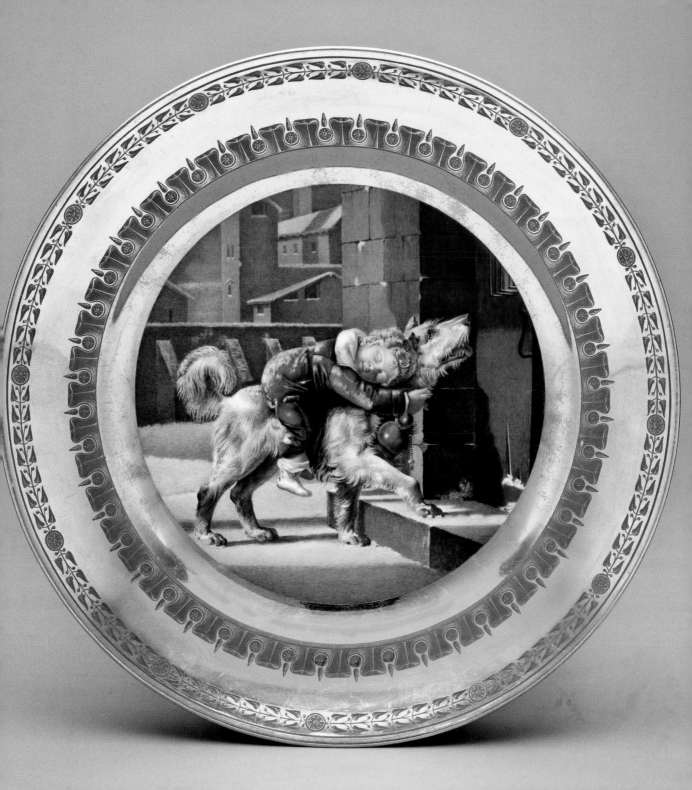

His encounter with his forty-first traveller in need proved tragic. With time this story acquired a lot of details and different versions, but in brief it goes like this.

Late in 1812, after suffering defeat in Russia, Napoleon's army retreated across the whole of Europe on its way back to France. Many mercenaries deserted from their regiments. One of them decided to cross the St Bernard pass in order to get to Italy (which may have been his homeland since there were Italian units in Napoleon's forces). On the pass he had the misfortune to fall into a crevasse. He could not get out and, worn out from his efforts, drifted off to sleep. A blizzard began and covered the unfortunate man. He was found and dug out by Barry. As usual, the dog began licking his face to bring him round. The soldier, still half-asleep, took the St Bernard for a predatory beast and plunged his sword into him. The wounded dog somehow managed to crawl back to the monastery. Following his trail, the monks found and rescued the soldier. But what about Barry? One version of the legend says that he died of his wound before the night was out. This account was perpetuated in the monument to the famous rescue dog set up at the animal cemetery in Paris.

Another version says that the great-hearted animal survived, but due to his age and his wound he was no longer able to continue working. Barry lived out his days as an honoured veteran in the Swiss capital, Berne, cosseted by the inhabitants.

Dogs have selflessly rescued people not just from deep snow, but also from fire. The first specially trained "fire-dogs" appeared in Britain in the nineteenth century.

Barry the Saint Bernard
Natural History Museum of the city of Berne
Switzerland

Across the world Saint Bernards are even today known as the best rescue dogs. Thanks to Barry's fame there are still breeding kennels associated with the Monastery of St Bernard.

Dogs of the Monastery of St Bernard
Photograph taken by Polina Otiugova
2009

The monastery's breeding kennels still operate, selling 15–20 puppies annually. A few years ago the monks decided to sell their dogs due to shortage of funds – every animal needs two kilos of meat a day apart from anything else. Two foundations, one named after Barry, were set up to ensure that the old traditions continued.

House fires were a very frequent occurrence back then, not surprising with heating stoves and open fires for heating, candles or oil lamps for lighting. The British noticed that most often it was children that lost their lives in fires. They would take fright and hide, and the firemen did not have the time to go hunting for children in the dense smoke: they had a fire to extinguish. On the other hand, this task was performed exceptionally well by specially trained dogs, although it is very difficult to sniff out a human being among so many unusual smells from different burning materials, and in a hot, frightening environment. A particularly notable London canine named Bob rescued twelve children from blazes. Fire brigades in some countries still have dogs on the staff.

Search and rescue dogs were particularly needed during the Second World War. After the bombing of cities in Britain, France and Germany many people were buried beneath collapsed houses. Only dogs could smell out humans beneath the smoking rubble. The experience gained in such situations proved useful in peace time, in the aftermath of earthquakes.

Dogs also come to people's aid in the water. Particularly notable in this respect is the Newfoundland breed from Canada's easternmost island. These good-natured, devoted giants are excellent swimmers: in one known incident a dog swam twenty kilometres supporting a person! Besides, they are not afraid of heights and will jump to a drowning person's aid from a bridge

A monument to scientific experiments

Sculptor: I.F. Bespalov. 1935

Probably the most famous scientist associated with dogs is the great physiologist Ivan Petrovich Pavlov, who studied the functioning of the digestive glands and conditioned reflexes (for which he was awarded the Nobel Prize in 1904), and later higher nerve activity. On Pavlov's initiative a memorial fountain to dogs was set up in the courtyard of the All-Union Institute of Experimental Medicine in Leningrad (St Petersburg). More accurately it is "a monument to scientific experiments".

A Doberman pinscher is elevated on a tall granite pedestal decorated with eight bronze dogs' heads and four bronze bas-reliefs.

The captions on the bas-reliefs were composed by Pavlov himself. One of them reads: "A dog may be sacrificed to science, but our dignity demands that it always and unfailingly be done without unnecessary suffering." The scientist obviously felt indebted to the canine race.

or allow themselves to be lowered from a helicopter. Newfoundlands are valued members of some water rescue teams.

Guide dogs or "seeing-eye" dogs might well be reckoned to be lifesavers too. Without them many blind people would be practically deprived of the chance to get about because of the danger of injury. The earliest known depiction of a guide dog has been found in the fifteenth-century Church of St Sebaldus in Nuremberg, but special schools for training these canine helpers appeared only in the early twentieth century, in Germany and Britain.

In a less direct way human lives have certainly been saved by dogs that participated in scientific experiments. These include the space programme. Before humans were sent into the unknown environment of space, scientists had to know what threats there were to health and how the organism was affected by weightlessness, vibrations, g forces and cosmic radiation. So

dogs reached outer space before humans. In July 1951 the first two dogs – Tsygan and Dezik – were sent up in a rocket from the Kapustin Yar launch site. At a height of 87 kilometres their air-tight cabin was detached and returned to Earth on a parachute. Although the canine pioneers returned safe and sound, information about this launch remained classified for almost forty years.

Officially it is considered that the first dog to go beyond the Earth's atmosphere was the mongrel Laika in November 1957. Inside the orbiting spaceship Laika had her own section, a cramped capsule, where food and water was supplied to her automatically. Sadly due to technical miscalculations the little dog became overheated and died.

After that other dogs visited space and came back – Belka and Strelka, Mushka and Pchiolka, Shutka and Kometa, Ugoliok and Veterok, and many others. The designers and physicians worked flat out, but it was still too early to send a human into space. Far from all the flights ended successfully.

And it was only when a husky named Zvezdochka returned safe and sound on 25 March 1961 that it was decided to launch the first man, Yury Gagarin, into space. So for humans the space age began almost ten years later than for dogs.

Belka and Strelka

Memorial Museum of Space Exploration, Moscow

The Vostok spaceship launched on 19 August 1960 carried into orbit the two mongrels Belka and Strelka dressed in special suits, one red, one green. Medical and biological instruments detected changes in the canine cosmonauts' organisms throughout the flight. The dogs were the first to fly around our planet and return successfully to Earth. They both lived to a ripe old age and Strelka produced many offspring.

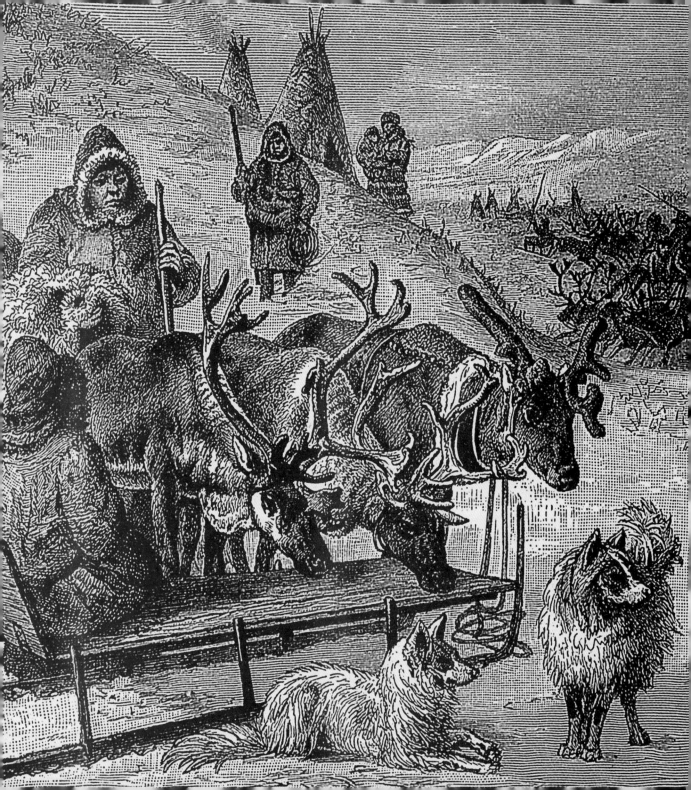

DRAUGHT DOGS

There are places on Earth where humans simply would not survive without dogs. Beyond the Arctic Circle the only form of transport were sleds drawn by reindeer or dogs. The local people claim that dogs are far hardier and less fussy than reindeer.

From time immemorial dogs were used as draught animals all around the shores of the Arctic Ocean: in the Far North of Europe, on Greenland, in Northern Canada and Alaska and on Kamchatka.

The oldest breed of this kind is considered to be the Chukchi Dog that goes back over 2,500 years. Like all indigenous canines they are undemanding with regard to food and keeping. The native peoples of the Chukchi peninsula, Chukchi and Eskimos, used dog sleds for moving loads and for seal hunting. The Chukchi dogs are unrivalled as racers too. The inhabitants of Alaska appreciated their good-nature, quick wits and endurance and they have been bred successfully in the US state since the early twentieth century.

The peoples of the North dote on their dogs: intelligent, hardy, obedient, reliable enough even to go bear-hunting with. Still today professional travellers prefer Chukchi dogs to any other draught animal.

Among the Eskimos of Greenland a team usually consisted of a dozen dogs (six pairs), headed by a well trained leader. The dogs were harnessed to a low wooden sled much like a boat using straps of seal or bear leather. Strips of bone were attached to the wooden runners to make the sled slide better over the snow, and in heavy frosts, when the snow was powdery, they also poured water on the runners.

Samoyeds with their dogs and reindeer
Engraving based on a photograph. Early 1900s. Detail

*In days gone the name Samoyed was used for several nomadic peoples
(the Nenets, Selkup and Nganasan) who lived along the coast of the Arctic Ocean
from the Kola peninsula to the Taimyr, across the whole of Siberia and the Far East.
"Samoyed" means "I am a human being". The Nenets draught dog – the oldest
of the Spitz-type dogs – are now also known as Samoyeds.*

Natives of the Kamchatka peninsula with a dog sled

An illustration from the 1755 book A Description of the Land of Kamchatka compiled by the student, and later professor, of St Petersburg University Stepan Krasheninnikov, who personally observed the way of life of the Kamchadal during the expedition of 1735–41.

The Kamchadal's sleds are narrow and tall, making it hard to keep one's balance. So women usually sit astride the sled, while men keep both legs on the right. If a rider fails to keep his seat during a turn or a steep descent, the dogs do not hang around; they keep running until their strength fails them or they reach a dwelling.

It is hard for the dogs to pull a sled across fresh loose snow, especially with a load. Then the driver puts on short hunting skis or snowshoes and tramps down the snow in front of the team. The speed is not very great, of course, but there is no other transport and no other way to carry loads. On the other hand, over a strong crust of ice, the tough Kamchatkan dogs run swiftly, covering almost 150 versts in a day.

The sharp-muzzled Eskimo huskies are very hardy. They have a good sense of direction in snow-covered wastes and unerringly sense the strength of ice in spring. These draught dogs are not adapted to life inside the home. Thanks to their thick coats they are not troubled by freezing temperatures and can stay outside all through the year.

In the extreme conditions of the Far North the help provided by dogs is invaluable.

In 1742 dog sleds carried Semion Cheliuskin to the northernmost point of the Asian continent. In 1909 dogs pulled Admiral Robert Peary's expedition to the North Pole. Two years later, 28 huskies helped the Norwegian Roald Amundsen to conquer the South Pole. When the

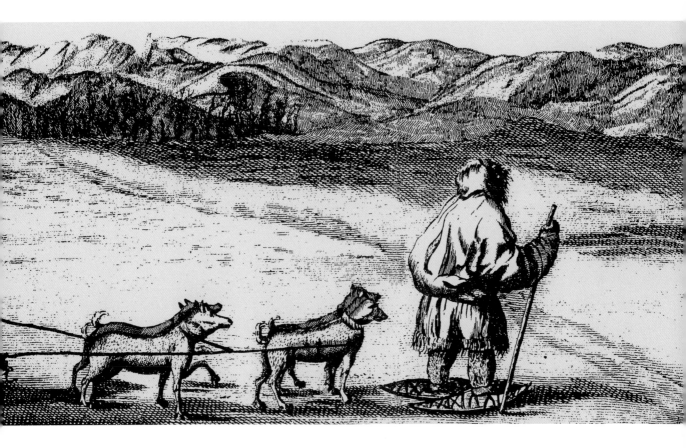

successful hero was being feted back in his homeland, he raised a toast to the dogs and said: "Look into a dog's eyes. You will see the same thing in them as in human eyes. Dogs definitely have what we call a soul."

Robert Scott's group set off at the same time as Amundsen's, but reached the pole a whole month later. This was to a considerable extend due to a plan that made little use of dogs, preferring ponies and two motorized sledges, and then man-hauling for the final part of the route to the pole. Scott's party perished on the return journey. This tragedy proved that huskies were the best alternative in polar conditions. No few instances are known of sled dogs saving people.

Alaska in the winter of 1925 was the setting for one such occurrence, the details of which are preserved in the Cleveland Museum of Natural History in Ohio.

In the small Northern Alaskan town of Nome on the shores of the icebound Bering Strait there was an outbreak of diphtheria, an infectious disease particularly dangerous to children. In order to prevent an epidemic a supply of the diphtheria antitoxin was urgently needed. But the local doctor's supply had expired. The doctor sent out a call for help by telegraph and the serum was delivered by train to Nenana, but that was still over 650 miles (1,000 kilometres) across rough country from Nome.

The fastest way would have been to deliver the medicine by air, but a blizzard was raging across the whole of Alaska and planes could not take off – back in those days they nearly all still had open cockpits. It was decided to carry the serum by a relay of dog sleds. Experienced "mushers" reckoned that, given the weather conditions, the journey might take up to a month.

The cross-country dash that became known as the "Great Race of Mercy" began. Each team covered a leg of 25 to 35 miles and passed on the precious serum to the next. Hardest of all was

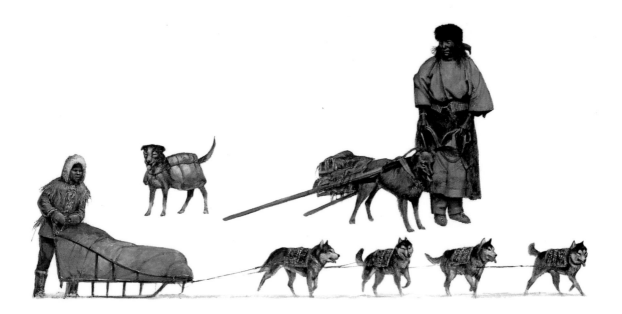

the final stage, across the frozen ice of the Bering Strait. It was accomplished by the musher Gunnar Kaasen and his team, led by a dog called Balto. Wind, driving snow and fifty degrees of frost. Towards the end, when the exhausted driver fell onto the sledge and lost consciousness, Balto kept the team going. He mounted the steep shore and only stopped when he reached the hospital. The whole distance from Nenana had been covered in just 127½ hours!

At the end of the same year a monument was unveiled in New York's Central Park. On a rocky pedestal is a bronze dog in harness. A metal plaque bears the following inscription: "BALTO. Dedicated to the indomitable spirit of the sled dogs that relayed antitoxin six hundred miles over rough ice, across treacherous waters, through Arctic blizzards from Nenana to the relief of stricken Nome in the Winter of 1925. Endurance - Fidelity - Intelligence."

Even today, when new means of transport have been invented, dog-power has still not become redundant. There are several reasons for that. First, the caterpillar tracks of all-terrain vehicles destroy the thin soil covering, which takes decades to recover in the permafrost zone. Secondly, dogs do not need spare parts or fuel and they do not break down from the cold.

The Draught Dogs of the Natives of North America

The North American Indians long ago trained dogs to carry loads on their backs or to pull travois or sleds. A Malamute sled dog is even depicted on the arms of Canada's Yukon Territory, where dogs were from time immemorial the main means of transport.

The monument to Balto in Central Park, New York. 1925

Present-day photograph

SNIFFER DOGS

The exceptional canine sense of smell and dogs' ability to doggedly follow a trail inspired humans to use them in yet another field – police work and detection.

From the late seventeenth century English dog breeders began to deliberately train dogs to track down robbers who hid in the woods and preyed on travellers. By the late nineteenth or early twentieth century German shepherds, collies, Airedale terriers and Doberman pinschers were already in service with the police forces of Germany, France, Belgium and the Netherlands. They found stolen goods, helped in the arrest of criminals and the guarding of prisoners, and detected hidden explosives.

On one occasion the Russian journalist Vlas Doroshevich watched with fascination a public demonstration performance by police dogs. He saw a dog choose one of ten identical chests

Training a dog on the Semionovsky Regimental Parade Ground
St Petersburg. 1913

The famous Tref
Russia. Photograph. 1910–14

In three years Tref helped to solve around 1,500 crimes. Once the dog trailed three criminals for 115 kilometres – and caught up with them. Tref's children, who later served with the Moscow detective force, proved no less talented.

and bark at it. That chest contained dynamite. Then they made things harder: "They brought three iron chests, in each of which they placed a large wooden one, then a small wooden one inside again. All were closed up. The dog indicated one of the chests. When it was opened there was dynamite within."

The police department of the Russian Empire took a great interest in the work of its European colleagues. In 1907, Vladimir Lebedev, the head of the criminal investigation section of the St Petersburg police, began the training of police dogs at Peterhof. Soon the first public trials of graduates from the Detection Dog School took place. A diploma with honours was awarded to the 11-month-old Doberman pinscher Tref, trained by the experienced police inspector Dmitriyev. The other 25 graduates were sent to serve in large provincial centres.

By 1915 dogs had become an indispensible element in the Russian detectives' arsenal. Prominent specialists from the West came to see the Russian trainers at work and the skills of the police dogs.

Still today sniffer dogs are used by police forces, on frontiers and by the customs. They find arms, explosives and drugs among the freight, saving people from other people.

THE DOGS OF THE HOUSE OF ROMANOV

Almost all members of the Russian Romanov ruling family had packs of pedigree hunting dogs carefully selected and well trained by the imperial huntsmen. That is only natural as hunting was an important leisure activity for the rulers and at times also an element of diplomacy. And where there is hunting there are dogs. But the Romanovs also had very different dogs. These were the canine companions that lived in the imperial apartments. Members of the family were very deeply attached to their pets.

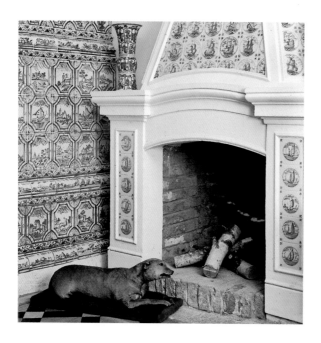

The Tsar's dog by the fire in the recreated Winter Palace of Peter the Great

Dog
Exact copy of an early eighteenth-century Dutch tile

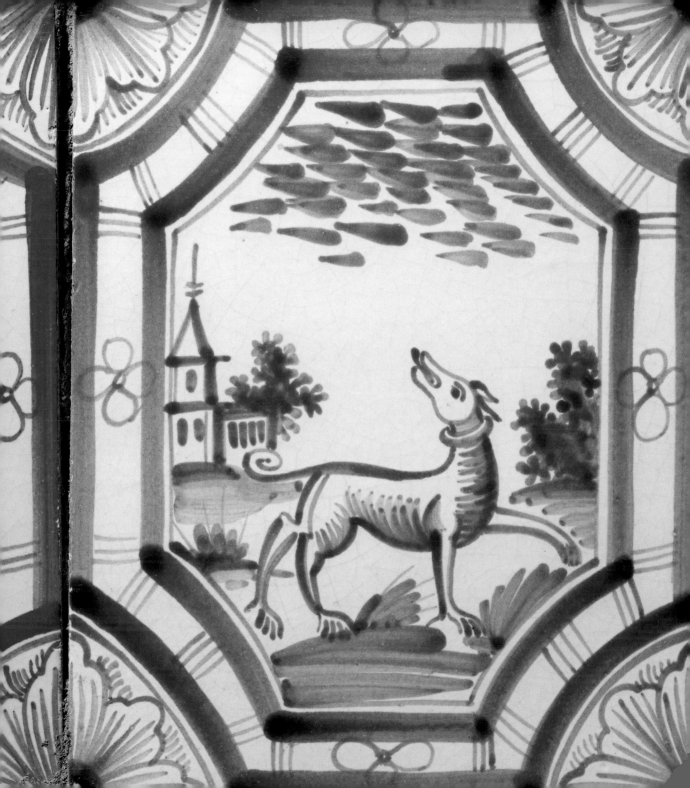

In Europe toy dogs came into fashion in the 1600s, in Russia at the end of the century in the time of Peter the Great. It was then that dogs began to be given individual names, which is understandable – you need to be able to call a creature living alongside you!

History has only preserved quite meagre information about Peter the Great's dogs. We know that there was Lisetta, a small, light-coloured terrier that was a gift from his close friend Prince Menshikov, and Tyrant, a large dog with a grey shaggy coat belonging to the now extinct Danziger Bullenbeisser breed, which is one of the ancestors of today's Boxers. Tyrant went everywhere with the Tsar and, it is said, was able to deliver notes giving the Tsar's instructions to his close associates.

Peter was not a passionate animal-lover, but he became very strongly attached to these two dogs and even sometimes allowed them more than his human retinue. Once, according to Jacob Stählin, a chronicler of tales about Russia's first emperor, Peter's wife Catherine slipped a paper under Lisetta's collar containing a plea, written as if from the little dog, on behalf of an eminent courtier who had fallen into disfavour. Peter had forbidden anyone to speak out on the disgraced man's behalf. But since the petition was "submitted" by his beloved Lisetta and was delivered for the first time by such an original means, the Tsar appreciated this inventiveness and pardoned the offender.

But dogs, sadly, do not live as long as humans. After Lisetta's death, Peter, who was devoid of any sentimentality, ordered that the dog be stuffed, as if to prolong her life. Lisetta's second life has lasted for more than 300 years now and she can presently be seen in St Petersburg's Zoological Museum. Another of the Tsar's dogs occupies and honourable place in the display of the Winter Palace of Peter the Great, part of the Hermitage complex.

No information has survived about any canine companions of Peter's daughter, Empress Elizabeth, although she was passionately fond of hunting and certainly knew a lot about dogs.

On the other hand, we know a good deal about Catherine the Great's pet dogs. This Empress liked animals generally and people who treated animals well enjoyed her favour. At first in Russia, when she was still a Grand Duchess, she did not have any personal dogs: they all belonged to her husband, the grandson of Peter the Great and future Emperor Peter III, and he, to her despair, was cruel to them. In her memoirs Catherine describes how he trained them, chasing them with a whip from one corner of the room to another, and how he beat a little

Lisetta snuffbox
Johann Gottlieb Scharff. Russia. 1780s

An Italian Greyhound
Imperial Porcelain Factory, Russia. 18th century

toy dog with a stick. She begged her husband to be kinder, but was ignored. Still, that did not prevent him from giving his wife her first dog, and exactly the sort that she had wanted – a little English poodle. This gift was chosen very carefully and with understanding.

It was a very intelligent dog, clean in its habits and also very amusing, having learnt a host of tricks. It was able to wear clothing specially sewn for it by the maids-of-honour, to sit at the table with a napkin tied around its neck and to eat tidily from a plate. Sometimes it jumped onto the table to take a pie and then returned to its place. The poodle was looked after at first by one of the palace stokers named Ivan Ivan(ov)ich, and the poodle also became known as Ivan Ivanich. But, as fate would have it, those were also the name and patronymic of the young Shuvalov

whose star was in the ascendancy due to Empress Elizabeth's affection for him. Shuvalov was envied by many at court. When it became known what name the dog presented to the Grand Duchess had been given and how displeased Empress Elizabeth was about it, almost every lady in the city acquired a poodle with the selfsame name. And they all liked to loudly order their Ivan Ivaniches about. Catherine had an awkward interview with the Empress, seeking to prove that this was none of her doing.

Then, when she was Empress Catherine II, she kept Italian greyhounds or whippets. One of them was a gift from the prominent banker Sutherland and in gratitude was given his name. This gave rise to a tragicomic episode that contemporaries liked to recall. When the dog died, Catherine ordered that Sutherland should be stuffed at once. As the French ambassador, Louis Philippe, Comte de Ségur, relates a terrible misunderstanding occurred: the order was taken literally. The horrified Chief of Police informed the banker, giving him a quarter of an hour to set his affairs in order. Of course, the truth quickly came out: the banker was released from custody, but the "strange" incident lived long in the memory of the court.

Gold snuffbox in the form of a pugdog
Unknown craftsman. Russia. 1760s

Porcelain snuffbox bearing a depiction of pugs
Made by Dmitry Vinogradov. Painted by Andrei Cherny. Russia. 1752

This was the first article produced by a Russian porcelain factory. For Empress Elizabeth's birthday the box was decorated with images of her favourite dogs.

It must be said that Catherine's pet dogs lived a royal existence. They slept in little satin cradles in the Empress's bedchamber. They were allocated their own team of servants, who were attached to "Her Majesty's personal affairs" and answered not to their superiors in the hierarchy of huntsmen but directly to the Empress.

The union of two beloved pets, Sir Tom Anderson and Lady (who was probably also known as Duchess), gave the Empress her favourite – Zemira, named after the heroine of Grétry's opera *Zémire et Azor*. We know much to the credit of Zemira, who was "a little irritable, but her heart was kind", from the epitaph composed for her by Ségur at Catherine's request. That whimsical text ends with the phrase: "The gods, who witnessed her tenderness, should have rewarded her loyalty with immortality, so that she might remain constantly at her mistress's side." The fourteen lines extolling Zemira in French were engraved on her pyramid-shaped tomb (designed by the architect Adam Menelaws) in the park at Tsarkoye Selo. An early twentieth-century guidebook noted that "This inscription is still visible, although indistinct, on a stone plaque behind the pyramidal mausoleum." The erection of this monument started a tradition of burying the four-legged friends of the imperial family with all due honours. Catherine herself composed the epitaph for another of her favourites – Lady, Zemira's mother:

> *Beneath this stone lies*
> *Duchess Anderson,*
> *who bit*
> *the skilled Rogerson.*

It's not great poetry, but it is sincere and gives a neat characterization of the Duchess, who once nipped the Empress's Scottish personal physician.

No information survives about Paul I's personal dogs. Most probably he simply did not dare to take a pet, fearing that such a demonstration of free will would evoke the displeasure of his mother, Catherine II, given their strained relations. Paul was, however, fond of dogs and regretted not having his "own faithful poodle". He even allowed stray dogs to go in front of his person at the changing of the guard.

It was thanks to Paul that applied dog-breeding began in Russia. In 1797 the Emperor signed a decree on the purchase in Spain of the sheepdogs that had been bred there so as to protect the flocks of fine-fleeced sheep being grazed in the Crimean steppes, where wolves were

**Catherine II Strolling
in the Tsarskoye Selo park**

Vladimir Borovikovsky
Russia. 1791

*The Empress liked to take her
pet dogs for walks herself. Here
she is depicted with an Italian
greyhound that looks devotedly up
at its mistress. Perhaps it is
the celebrated Zemira.*

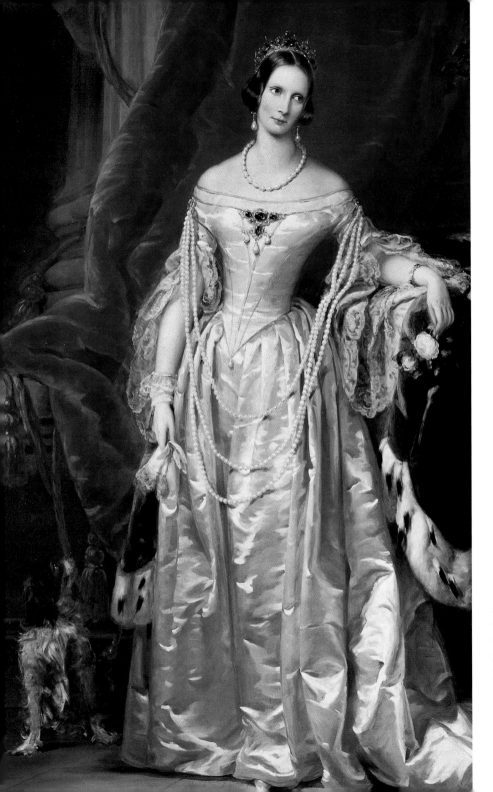

**Portrait of Empress
Alexandra Fiodorovna
with her favourite dog**
Christina Robertson
Britain. 1840–41
Detail

a serious problem. But by the time his orders were carried out his son, Alexander I, had come to the throne.

Alexander I is the only Russian emperor whose name is not mentioned in connection with dogs, although many recalled his kindness towards animals generally. When he was at Tsarskoye Selo, for example, he would always go down to the Great Lake at a specific time in the morning and, after putting on a special glove, feed the ducks and geese that made a great noise as soon as the Emperor appeared.

Nicholas I's arrival on the throne marked the start of the Golden Age of love for canine companions. The Emperor's best known dog was the extremely bright silver poodle Hussar. This loyal friend never left his master and sometimes even worked as a messenger: if Nicholas

Cupid with an Italian greyhound
Inkstand
Imperial Porcelain Factory, Russia
1810s–20s

wanted to see someone, he just said their name. Hussar would find the right person, tug at their hem and bring them to the Emperor.

He had learnt such tricks at an early age. Before becoming the Emperor's Hussar, he had been the educated canine Monito performing at the circus in Bohemian Karlsbad. The talented dog's fame reached the ear of Dmitry Tatishchev, the Russian ambassador in Vienna. He bought the four-legged celebrity and presented him to Nicholas I. It was, incidentally, established tradition that Russian rulers did not buy their pet dogs, but usually received them as a gift from courtiers, relatives, loyal subjects, admirers or friends.

Later, a bronze memorial sculpture of Monito was set up in the Alexander Garden at Tsarskoye Selo and the imperial pet dogs were buried near it. In the time of the last Emperor, the site of the cemetery was changed to the Children's Island in the Alexander Park. All the following emperors fed their dogs themselves, walked and played with them. This is confirmed by many diary entries and the memoirs of contemporaries. The maid-of-honour Alexandra Smirnova-Rosset watched for a long time as Nicholas I repeatedly threw a handkerchief into a pond for his Irish retriever and the delighted dog brought it back to his master.

This was on the day that the Decembrists were executed and the Emperor was clearly nervous. The dog understood nothing of his master's anxiety and was very confused when, after finally receiving the news that the business was over, the Emperor hurriedly returned to the palace. The dog had to drop the handkerchief at the feet of a man-servant.

Alexander II was also a passionate dog-lover. In his youth he had Mulia, who accompanied him on his travels around Russia and Europe, then the Italian greyhound Mok or Moksik. Maid-of-honour Anna Tiutcheva recalled that Moksik liked only one particular kind of biscuit that had been soaked in milk, and on the Emperor's orders invariably received his favourite fare.

And there was also Punch, "Loyal Punch" as he was characterized with manly brevity in his epitaph.

The poodle Hussar on the shore of the Gulf of Finland
Georg Ferdinand Weckler. Russia. 1847
Mosaic

Later Alexander II acquired Milord, a black setter with a single white paw, given to him by a Polish landowner. There were rumours that Milord was not quite a pedigree dog, but that did not worry his master.

The Emperor was never parted from him. He went for walks with the dog in the Summer Garden and even took him to concerts.

The whole of St Petersburg knew Milord. Touching and amusing stories about him went the rounds of the city and are touchingly recounted in the *Historical Bulletin*.

Emperor Alexander II and his setter Milord
Sergei Levitsky
Russia. Photograph, 1866

Portrait of Grand Duchess
Maria Alexandrovna
Christina Robertson
Britain. 1850

This watercolour portrait of the wife of Alexander II,
made before her husband came to the throne, shows
her with her favourite Italian greyhound − the same
one that appears overleaf in the collective portrait of
the imperial dogs by Alexander Schwabe.

One of them has Milord eating a home-baked name-day biscuit that a schoolboy was carrying as a gift for his grandmother and accidentally dropped when he saluted the Emperor. Alexander comforted the weeping lad, taking the blame upon himself for not having made sure the dog was well fed before taking him out for a walk. And on the Emperor's orders a splendid cake from the best baker's shop was delivered to the grandmother.

Like all setters, Milord needed constant close contact with his owner and was hardly ever parted from him. When Alexander II left for the World Exhibition in Paris he was persuaded with much difficulty not to take the dog with him due to the length of the journey. Milord died

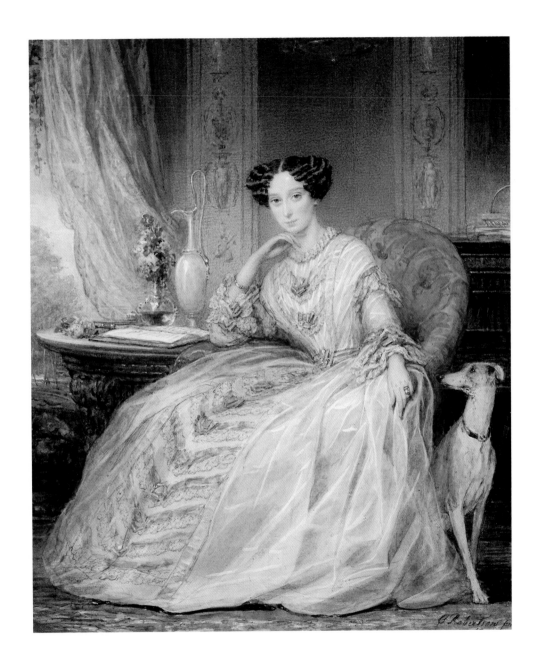

of a broken heart, deciding that he had been left for ever. The news of the dog's death was kept from Alexander until his return out of concern that a look of sadness on the Emperor's face might be put down to circumstances of a political nature. Of course, the Tsar grieved deeply, when he was finally told.

But Milord's descendants continued to increase in number and delight their owner. The noted historian of dog-breeding in Russia Leonid Sabaneyev claimed that one of Milord's puppies grew up on the estate of Count Leo Tolstoy.

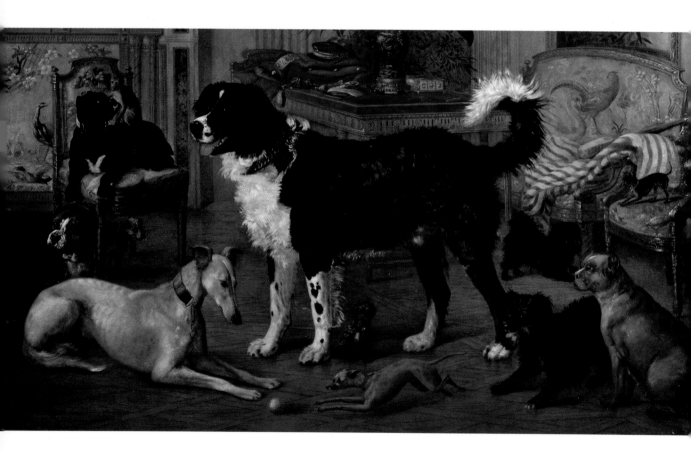

Emperor Alexander III was extraordinarily attached to a Kamchatkan sled dog called Kamchatka that according to family diaries was a gift to him from the sailors of the cruiser *Africa*. They spent many happy days together. The dog went everywhere with Alexander and even spent its nights in the Tsar's bedroom at the Anichkov Palace, despite the objections of doctors.

St Petersburg magazines of the period often carried photographs of this far from regal canine and his wonderful speckled muzzle invariably touched the heartstrings of the public.

The Pets of the Imperial Family
Alexander Schwabe. Russia. 1867

In the interior of the study of Alexander II's brother Grand Duke Konstantin Nikolayevich in the Pavlovsk palace the court artist assembled at the Emperor's request a collective portrait of the family's real-life pets. They belong to a wide variety of breeds – Italian greyhound and bulldog, Chihuahua and Welsh terrier, Cairn terrier and whippet, and in the centre a Newfoundland that belonged to the Tsar himself.

Boy with a Dog
From a model by August Spies
Imperial Porcelain Factory, Russia. 1872

Hand Fan for Outdoor Use
Austria. 1880s

*The guards at either end of this wooden fan are embellished
with carved bulldog heads. The fan was presented to Empress
Maria Fiodorovna as a memento (the slats bear the date
27 February 1883).*

**Grand Duke Alexander Alexandrovich,
the future Alexander III, with his bulldog** ►
Russia. Photograph. 1878

**The family of Emperor Alexander III:
his wife Maria Fiodorovna and children Georgy,
Xenia and Nicholas**
Russia. Photograph. 1886–87

Kamchatka was tragically killed when the imperial train crashed near Kharkov in the Ukraine, an accident that Alexander and his family only survived by a miracle. "Do I have even one selfless friend among people? No, and there cannot be one, but a dog can," Alexander III wrote.

But the record for the largest number of pets must go to the family of Nicholas II. As soon as the children had grown up a little, they were given dogs or cats, and since there were five children there were no few pets. Grand Duchess Tatiana had a French bulldog named Ortipo, a present from a wounded officer in October 1914 (looking after the wounded became a daily task for the Tsar's older daughters who worked as nurses in a military hospital following the outbreak of the First World War). Tsesarevich Alexei had a dog called Shot of unknown breed and then a spaniel named Joy. Anastasia had a King Charles spaniel called Jimmy and before him a charming creature of obscure ancestry, Shvybzik that was very young and not properly house-trained. He would "do his business" right on the carpet in the middle of the room, so that the girls had to clean up after the puppy using the little shovel from the fire irons.

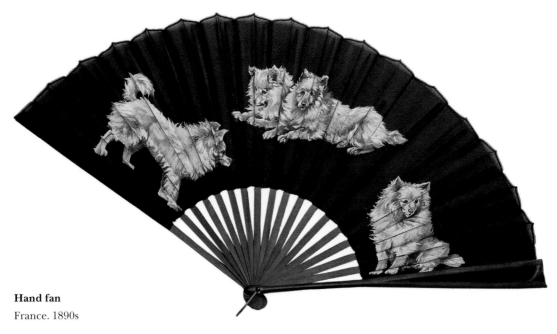

Hand fan
France. 1890s

This fan also belonged to Empress Maria Fiodorovna. Its black grenadine leaf carries depictions of Pomeranians executed in gouache.

Tsesarevich Alexei with Joy ▶
Russia. Photograph. 1914

Empress Alexandra Fiodorovna had a Scotch terrier called Eira, while Nicholas himself had two beloved collies Voron and Iman (a Christmas present from his sister-in-law). There is a sympathetic and eloquent entry in Nicholas's surviving diaries about one wintertime walk: "Stupid Iman fell through a hole in the ice, but he pulled himself out straight away and ended up like a great big icicle."

When the former imperial family were moved to Siberia, they took their dogs with them as they did on all long journeys. Three cats remained at home, but Ortipo, Jimmy and Joy went off to Tobolsk.

The children were not parted from their dogs until the very end. Jimmy died in the cellar of the Ipatyev house in Yekaterinburg, but the bulldog Ortipo and the spaniel Joy survived.

Stuffed toy of a dog
Russia. Early 1900s

This toy belonged to Nicholas II's children.

Ortipo remained upstairs in an empty room and howled for the whole district to hear, while Joy, reserved by nature, was silent with terror and they left him untouched. The spaniel was the luckiest of all; his fate took an incredible turn.

When the White army took Yekaterinburg a few days later, Joy was found by the officer Pavel Rodzianko, who eventually took him to England and gave him to King George. The spaniel was adopted by the English court, where one of the last Russian Empress's sisters was living.

Thus ended the Russian history of the dogs of the House of Romanov.

MAN'S BEST FRIEND

Dogs have long since become an inseparable part of everyday human life. This is reflected even in the paintings of Old Masters.

Dogs accompany people on walks and outings and take part in domestic amusements. They feel quite at home in distinguished company in the drawing-room and in the kitchen with the servants, in palatial halls and at the market. Here is one romping at an outdoor village celebration; another watches carefully as skates are put on. Another still sleeps calmly, curled up in a chair, or on its mistress's lap in the midst of a noisy feast. The dog, as a true and loyal friend, is always close by – and people are glad of its company.

Good Friends
Albert Edelfelt. Finland. 1881
Detail

Little dog scent flask
London, England
'The Girl in the Swing' factory. 1754–59

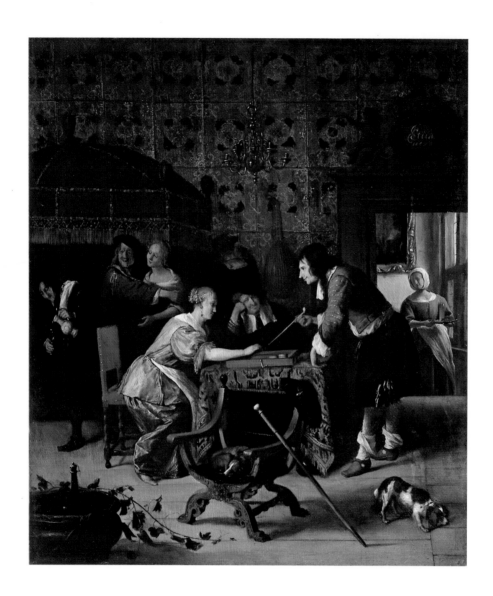

A Game of Backgammon

Jan Steen. Holland. 1667

Dog
Part of the decoration of an andiron (firedog)
Italy. 13th century

The Kitchen
David Teniers the Younger
Flanders. 1646
Detail

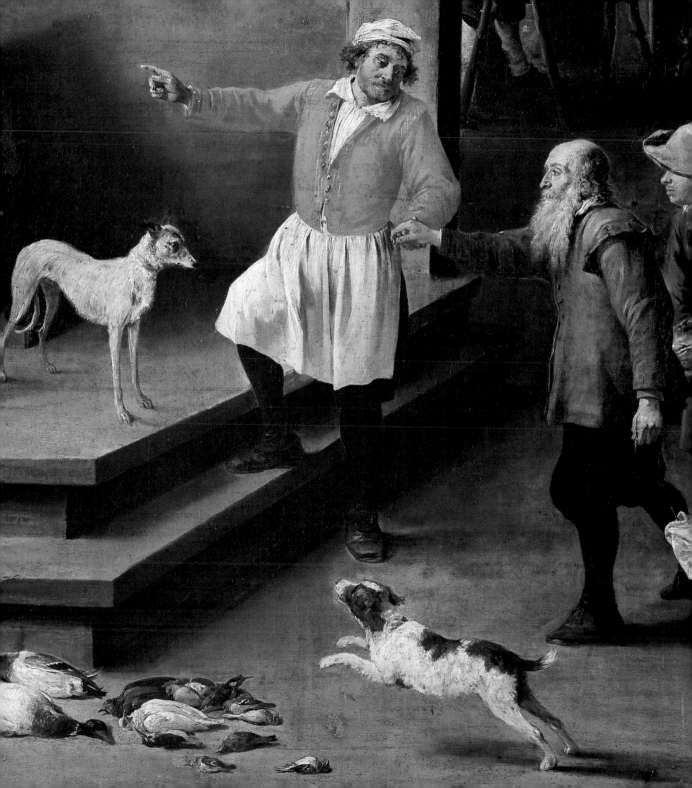

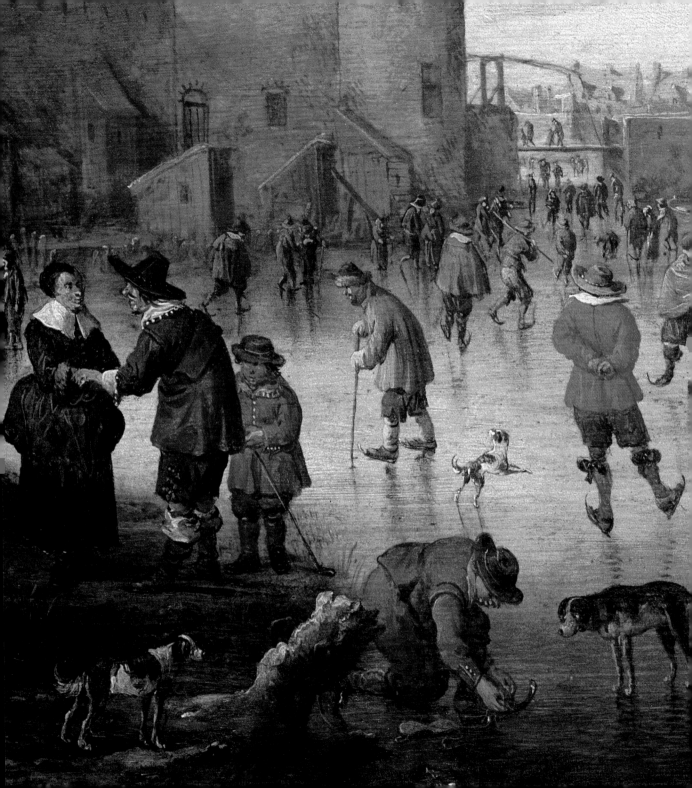

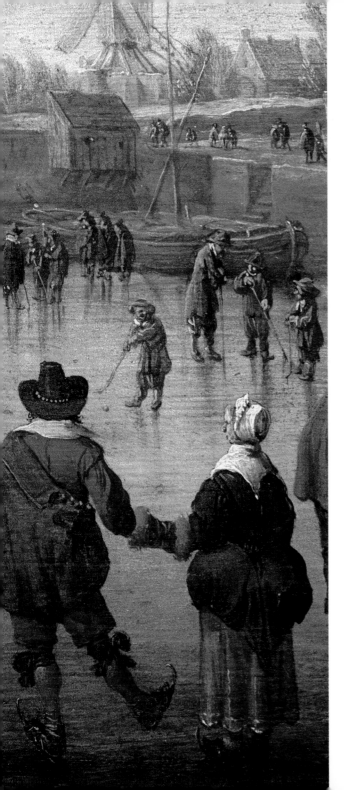

Winter in a Dutch Town
Joost Conelisz Droochsloot. Holland. 17th century
Detail

Scratching Dog
Sand sprinkler (for drying ink). Germany. 1550s

Following double page (186-187)
Peasant Holiday
Roelant Savery
Flanders. 1606
Detail

There are dogs that provide no particular service, yet people become attached to them with all their hearts, perhaps even more strongly than to working dogs. We are talking now about companion dogs, especially toy dogs that have been bred for a life in the home. It might seem that they need people more than people need them, but that is not true. The emotional warmth and tenderness that such pets give to people is beyond price.

In Europe the fashion for toy dogs emerged in the seventeenth century. But already in Ancient Egypt small companion dogs were specially bred and trained for the pharaohs. Their descendants are now known as Italian greyhounds. Basically they are hunting dogs only reduced in size.

The Ancient Egyptian companion dogs were particularly respected and even considered holy, thanks to their kinship with Anubis. After death they were embalmed and ceremonially buried. In the tomb of Pharaoh Psamtik I, next to the mummy of his wife, archaeologists found a mummified toy hound – dating from the seventh century BC!

A touching tale (probably legendary) was recounted by the Greek historian and writer Herodotus. When the forces of King Cambyses of Persia conquered Egypt in the sixth century BC, Pharaoh Psamtik III committed suicide. But that was not enough for the Persians. The invaders executed the Pharaoh's elder sons; then they took the youngest out into the desert and abandoned him there. His only companion was his beloved pet dog. That night loyal servants decided to go out secretly to look for the boy – and they found him: the loyal hound had remained steadfastly by its master's side. It shivered so much from the cold of the desert night that the little bells attached to its collar rang out loudly. It was this noise that guided the rescuers. Many have suggested, the writer went on with a certain degree of doubt, that the slight shivering typical of the breed appeared at that very time.

In the first century BC these companion dogs travelled from Egypt to Europe. The first are reckoned to be ones that Queen Cleopatra presented to Julius Caesar. The graceful, easily trained little hounds became great favourites with the Roman aristocracy and later with the elite of mediaeval Italy.

Cleopatra's Feast
Jacob Jordaens. Flanders. 1653. Detail

The fashion for Italian greyhounds reached its height in the eighteenth century, when there was probably not a monarch in Europe who looked unfavourably upon these miniature hounds.

King Frederick the Great of Prussia (1712–1786) had a favourite Italian greyhound called Biche that lived in his apartments, slept in his bed and accompanied him on walks, on campaigns and into battle. On the King's orders the courtiers addressed Biche in French with the respectful vous form of the verb. It so happened that by an oversight at the end of Prussia's war against Austria the dog ended up in enemy hands. When he concluded the Peace of Dresden, Frederick's demands were that the Austrians cede Silesia to him and immediately return Biche. When his pet reached the end of her natural life, the King had her buried in the park at Sans-Souci, his summer residence.

It has been suggested, though, that the fondness for Italian greyhounds among high society ladies was not entirely unselfish. The huge elaborate hairstyles sported by women of fashion in the eighteenth century took many hours to create and so they tried to keep them as long as possible. Since they washed and combed their hair quite rarely, it became infested with insects that

◄ **Misunderstanding**
Auguste Serrure. Belgium. 1855
Detail

Italian Greyhound
After a 1780s model by Jacques Dominique Rachette
Imperial Porcelain Factory, Russia
Late 1820s – 1830s

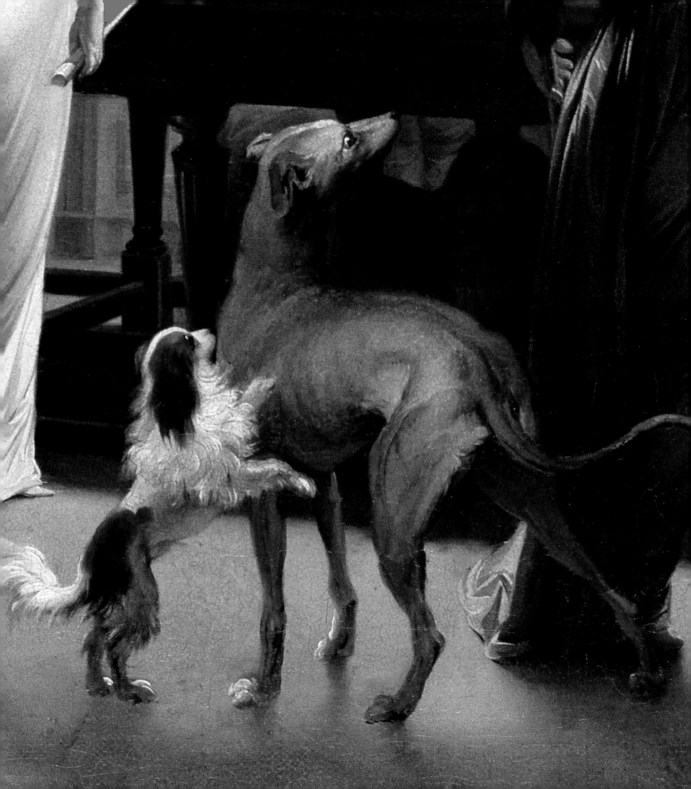

the dogs helped them to get rid of. Since Italian greyhounds have a higher body temperature than humans, the insects happily moved on to a warmer hairy surface. And it was far easier to remove lice and fleas from the short coat of a dog than from the long hairs of a lady's coiffure.

The Italian greyhound's only real rival in the popularity stakes was the Maltese. These little long haired dogs came originally from the central Mediterranean area – from Malta, or perhaps the Croatian island of Mljet or some other place with a similar name. From Ancient Roman times they were considered a sumptuous gift for a ruler of any rank. They came to Russia by way of France. Despite the fact that they are known for their difficult temperament (over-excitable and aggressive towards strangers) they easily managed to ingratiate themselves at the court of Queen Elizabeth I of England and at the Russian court.

Game of Billiards
Louis Léopold Boilly
France. 1807
Detail

A Gift
Marguerite Gérard
France. 1788
Detail

Girl with a Dalmatian Puppy
Porcelain scent flask
St James Factory of Charles Gouyn, London, England. 1750s

Dalmatians belong to an old breed that spread right across
the Mediterranean basin. They are the largest of the decorative breeds of dog.
Their elegance and distinctive colouring long ago attracted both aristocrats
and artists.

Lady with a Pug and a Suitor ▶
Porcelain statuette after a model by Johann Joachim Kändler
Meissen, Germany. 1737

In the middle of the sixteenth century the first *pugs* – a miniature version of ancient guard dogs – reached Europe from Turkey. The short-muzzled pugs were intelligent and highly affectionate, while at the same time retaining their guard-dog instincts and jealously protecting their mistresses. Pugs were especially prized in the Netherlands, since their colouring – sandy with black faces – bore a supposed resemblance to the dynastic colours of the ruling House of Orange.

In the 1880s the British introduced Europe to another breed of toy dog of fairly exotic origin and appearance. In its Chinese homeland it was known as the "lion dog" and considered the offspring of a lion and a monkey.

The life that members of the breed lived in the imperial palace of the enclosed Forbidden City was quite extraordinary. They were considered the personal property of the imperial family. Taking these dogs outside the imperial palace was forbidden on pain of death. Their entire lives were accompanied by many rituals.

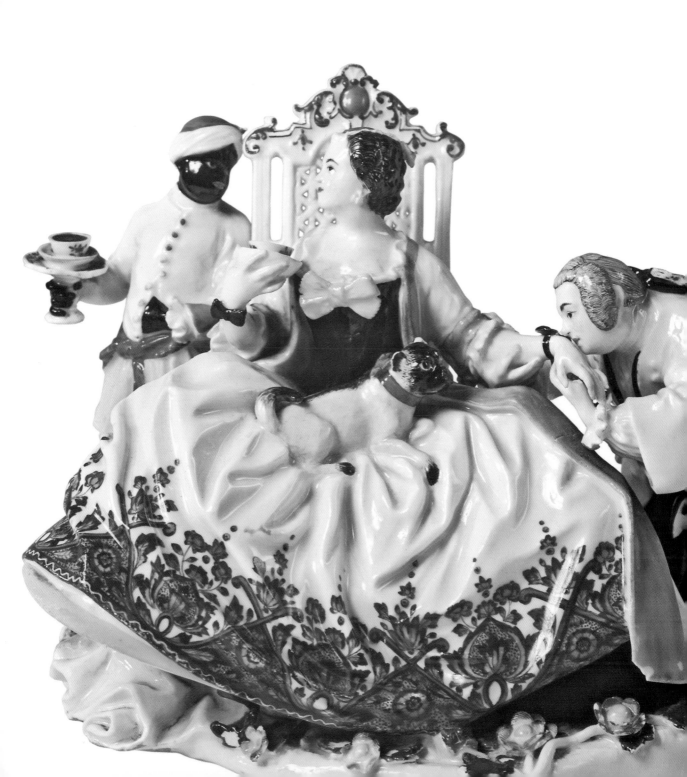

In the mornings they had their teeth cleaned and their claws manicured. Then they were allowed into the Empress's apartments, where they greeted the mistress by raining their paws and playing bells suspended from a special bar. Four dogs made up the personal guard of the Emperor and accompanied him everywhere.

And so it went on for centuries. But in 1860 an Anglo-French force captured Peking. The Forbidden City was looted and the ruler of the Celestial Empire fled into the interior of the country. In the haste, however, a few "lion dogs" were left behind in the palace. They were discovered in the park by some English officers (Hay, Fitzroy and Dunne) and in time brought back to Britain.

The breed became known as Pekingese, or Pekes for short. For a long time they remained a great rarity in Europe and fantastically expensive. Nowadays, though, it is no surprise to find them in an ordinary home.

◄ A wish for sons and grandsons for 10,000 generations
Chinese folk picture
Late 19th – early 20th century

The depiction of a gourd in Chinese pictures expresses a wish for a large number of descendants (each shoot produce a large number of fruit), while a dog means a wish that the recipient will live to a ripe old age.
The name "lion dog" comes from an old legend about the breed's origins. It says that once the emperor of the lions became smitten with love for an enchanting little monkey. But how could they be together, when he was so huge and she was so tiny? The love-sick lion, who was skilled in magic, made himself small. The offspring of their love inherited from its father, regal calm, an independent spirit and a luxuriant mane, from its mother playfulness, cunning and large dark – almost human – eyes.

Yatsushi Sanseki Saigyo
Isoda Koryusai
Japan. 1760s–70s
Detail

Other four-legged domestic companions with a very long history include poodles, miniature pinschers, sharp-muzzled Pomeranians (even used at one time as "hot-water bottles" – Poms have a body temperature several degrees higher than humans and are just of the right size), French bulldogs and Mexican Chihuahuas – the smallest breed of dog with a height of 17–20 centimetres.

They brightened the leisure hours of high society ladies and therefore portraits of women with their beloved pets were in great vogue in Europe. A portrait might testify to the wealth and pretensions of the mistress, and also to her tastes and attachments.

Sweet Sleep
Elisabeth Claire
Tournay
France. 1760s–70s
Detail

Portrait of the Sons of the Comte de Béthune
Jacques Firmin
Beauvarlet. Engraving
after a drawing
by François Hubert
Drouais
France. Second half
of the 18th century
Detail

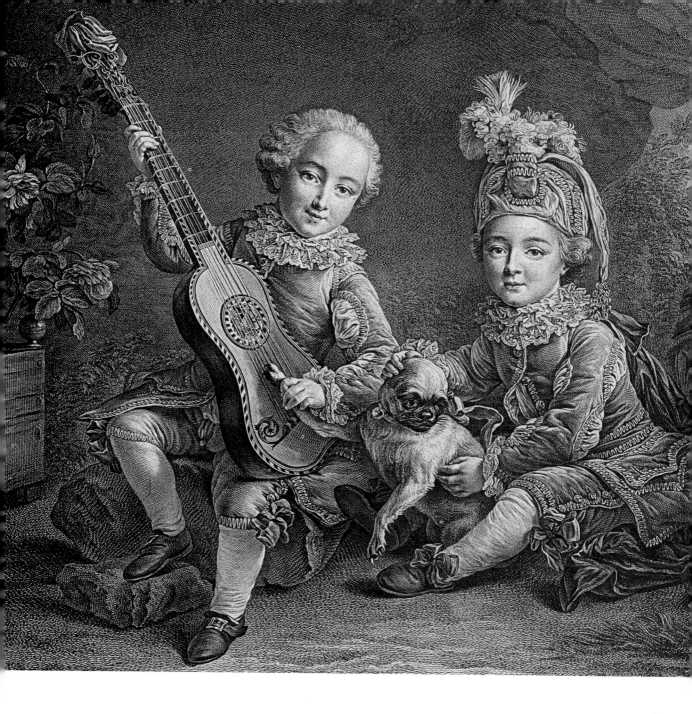

Lady at Her Toilet

Frans van Mieris the Elder

Holland. Circa 1659–60

Some people cannot resist the temptation to teach their pet to do tricks:
to "shake hands", sit up and beg, and so on. And they take pleasure in the clever,
amusing way the dog performs..

hiladelphia Wharton and Elizabeth

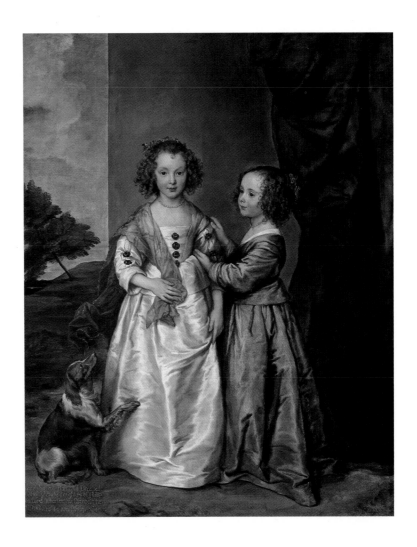

**Portrait of Philadelphia
and Elizabeth Wharton**
Anthony van Dyck
Flanders. 1640

But dogs look most natural in the company of children. Children are not concerned with breeds or fashions. The important things are openness and mutual affection, and canine loyalty, the extent of which does not depend at all on size or pedigree. You can make friends with the most mixed-breed mongrel and understand each other without words.

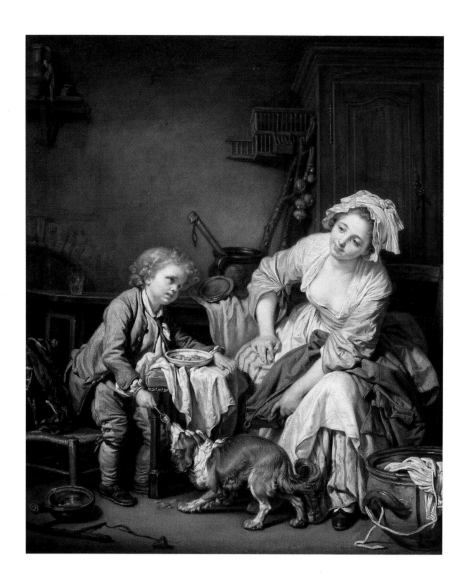

The Spoilt Child

Jean-Baptiste Greuze. France. 1760s

Boy Looking for Fleas on a Dog

Pedro Nunez del Villavicencio. Spain. 1650s

Boy with a Dog

Bartlomé Esteban Murillo. Spain
Between 1655 and 1660. Detail

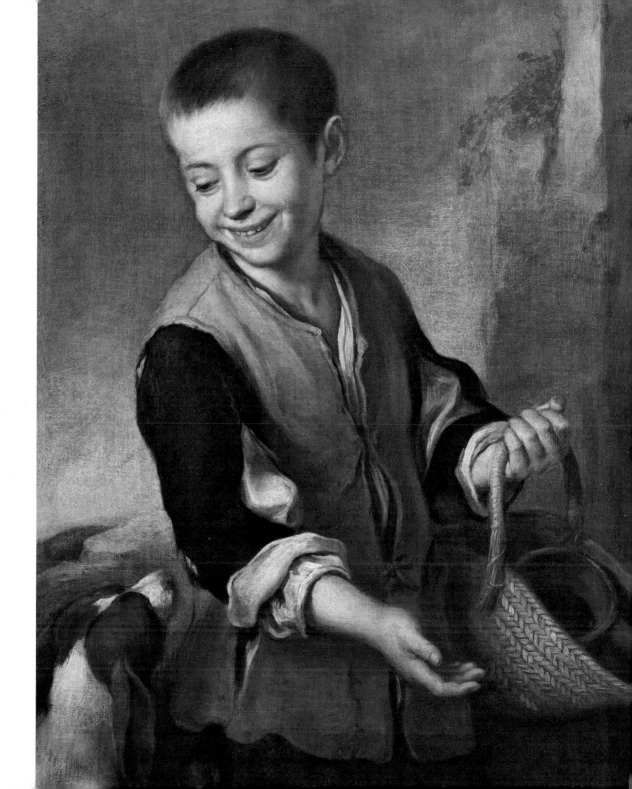

Nikolai Gol
Irina Mamonova
Maria Haltunen

THE HERMITAGE DOGS

Layout and Design
Olga Pen

Photographs
Leonard Heifetz, Vladimir Terebenin

Colour correction
Igor Bondar

Managing Editor
Yelena Streltsova

Artistic Editor
Vladimir Yakovlev

English Translation
Paul Williams

Translation Editor
Nina Zhutovsky

Consultant
Mikhail Surbeyev, President of the Sled-Dog
Racing Federation of St Petersburg

Printed and bound in India by Imprint Digital Ltd

ISBN 978-1-910065-679

Unicorn Publishing Group LLP
66 Charlotte Street
London, UK
www.unicornpress.org

First published by
ARCA Publishers in 2010
43 Moika Embankment
St Petersburg, 191065, Russia